SECRET
ISLINGTON
AND
CLERKENWELL

Lucy McMurdo

AMBERLEY

For Mac with love and gratitude.

First published 2024

Amberley Publishing
The Hill, Stroud
Gloucestershire, GL5 4EP

www.amberley-books.com

Copyright © Lucy McMurdo, 2024

The right of Lucy McMurdo to be identified as the
Author of this work has been asserted in accordance
with the Copyrights, Designs and Patents Act 1988.

ISBN 978 1 3981 1281 0 (print)
ISBN 978 1 3981 1282 7 (ebook)

British Library Cataloguing in Publication Data.
A catalogue record for this book is available from the
British Library.

Typesetting by SJmagic DESIGN SERVICES, India.
Printed in Great Britain.

Contents

Introduction

The London Borough of Islington, at only 6 square miles, is one of London's smallest boroughs, yet has the most exciting and fascinating history. Filled with the remains of monastic estates, and formerly famous for its sweet, clean waters, Islington has attracted people to the area from across the UK, as well as many from overseas, since medieval times. From the late 1600s Clerkenwell welcomed immigrants initially from France, then from Ireland, Italy, Prussia and Russia and all brought their trades and expertise here, contributing greatly to the local economy. Many were skilled craftsmen, and this has certainly left its mark – so much so that the quarter is now one of the country's major creative hubs, witnessed by its numerous design studios and architectural practices.

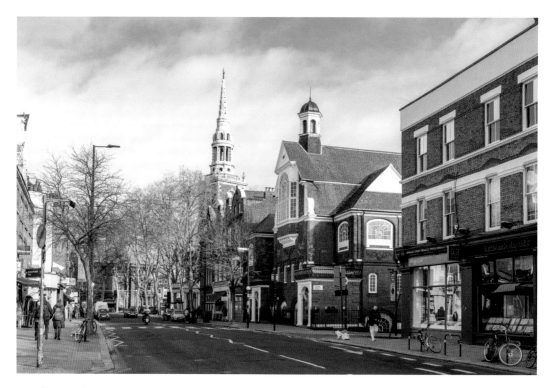

Upper Street.

Today the borough of Islington is made up of seventeen separate wards, many of which follow the lines of previous ancient villages and settlements, such as Archway, Holloway, Canonbury, Clerkenwell, Finsbury Park, Barnsbury, and Highbury. Yet to many Islington is regarded solely as the shopping area in and around Upper Street that stretches between Highbury and Islington and Angel underground stations.

For hundreds of years Islington was almost entirely rural except for its main road, the Great North Road (today's Holloway Road and Upper Street), which was lined with numerous taverns and hostelries. This was where the northern farmers bringing their cattle and sheep to the market at Smithfield (that by the sixteenth century had become the largest livestock market in the country) would rest with their animals before completing their journey into London. Local dairy farmers, renowned for their superior goods, were happy to provide pasturage for the sheep and cattle so long as they could hopefully get their pick of good stock and acquire milk from lactating cows. From Elizabethan times Islington's farms supplied the wealthy, as well as the Court, with their excellent and unadulterated milk, as well as with other luxury milk products such as baked custard tarts. The quality of Islington's milk trade and its proximity to the City of London naturally put it in good stead. Yet its remarkable success in the early to mid-nineteenth century was largely down to two men, Samuel Rhodes and Richard Laycock, who through the introduction of sanitation and efficiency measures revolutionised the milk industry and introduced the custom of milking cows under cover in purpose-built accommodation.

Upper Street.

 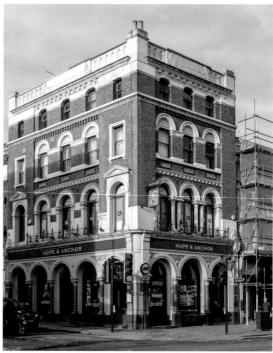

Above left: Former Hare and Hounds public house, Upper Street.

Above right: Hope and Anchor public house, Upper Street.

Their endeavours led to an even greater increase in the quantity of milkmaids who settled in the district, a large number of whom were from Wales. In fact, No. 37A Clerkenwell Green (today's Marx Memorial Library) was originally built as a school for Welsh children.

The Great North Road was always an important and busy route and in constant use. Along its way there were many inns and taverns, and people and goods were transported into the centre of London on horses, carts, and stagecoaches. In truth, not much has changed over the centuries except that today's vehicles are mainly buses, cars, trucks and bicycles and no cows or sheep now walk along its path.

Throughout the Middle Ages this main road was surrounded by fields and woodland areas and was largely a recreational area used by the aristocracy in their leisure pursuits. It remained fairly undeveloped until the 1800s, when due to industrial changes many new factories and manufacturing companies were established here, the Regent's Canal was built and then railways constructed. The railway allowed people to live further away from the workplace and commute to work and this led to the appearance of swathes of terrace houses – 'the march of bricks' when terrace after terrace was erected and, later, squares were built for the gentry.

Many industrial buildings appeared including wharves and depots beside the canal and warehouses around Smithfield Market. Beautiful Victorian buildings still stand from this time, many now repurposed but still displaying stunning architectural features and

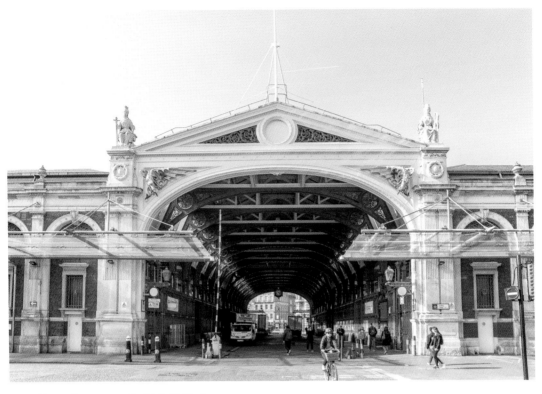

Above: Entrance to Smithfield Market.

Below: Cowcross Street.

ornamentation. Buildings like the former Finsbury Town Hall on Rosebery Avenue, the Union Chapel on Compton Terrace and Caledonian Tower are testament to the materials and designs employed by the architects of the time.

In contrast, there had been settlements in Clerkenwell for hundreds of years mainly due to its excellent access to water, the River Fleet. In fact, the Fleet was a most substantial body of water, second only to the Thames in size, and due to the number of wells built along its banks known as the 'River of Wells'. It flowed downhill from Hampstead Heath and joined the Thames through a marshy tidal basin over 100 metres wide at its mouth. Some of the Fleet's springs were believed to have curative qualities but by the thirteenth century the river's clear and sparkling waters began to cloud over and became polluted, and over time the river turned into an open sewer. During the nineteenth century it was covered over by tarmac and the river then continued its path underground until finally flowing into the Thames beside Blackfriars Bridge.

Situated just outside the walls of the City of London, Clerkenwell was an established settlement from the early Middle Ages and the Clerk's Well, after which the district gets its name, was the site of annual religious plays that attracted large audiences (including, it is said, royal visitors) from at least the eleventh century. From the late 1600s it was an area particularly attractive to refugee settlers unable to ply their trades in the City of London, who brought skills such as silk-weaving, precision engineering, horology, printing and engraving into Clerkenwell. For hundreds of years Smithfield, just beyond

Site of original Smithfield, today's West Smithfield.

today's borough boundaries, dominated the area occupying a site right beside the City walls. It was home to an annual fair from the twelfth to eighteenth centuries, a major site of execution in the sixteenth century and was London's main live meat market until the mid-1850s. Drovers from all over the country herded their beasts for slaughter here and the market itself and locale were described in Charles Dickens' book *Oliver Twist*: 'It was market morning. The ground was covered nearly ankle deep with filth and mire; and a thick steam, perpetually rising from the reeking bodies of the cattle, and mingling with the fog.'

As London's industry and population grew in the late 1700s the streets near the meat market were full of shops and warehouses where meat products were sold and stored. Butcher shops, meat traders and bacon curers were some of the businesses in Cowcross Street, the main route leading into Smithfield. The area became very densely populated, crime was rife, and housing conditions were so appalling that questions were asked about it in Parliament. How different the area looks today when former warehouses are now office space occupied by architectural practices, media and tech firms. Shops, pubs and restaurants are plentiful and the foul tenement buildings have long since gone. With the opening of the Elizabeth line at Farringdon station in 2022 Clerkenwell and Islington have been thrust into the limelight and Farringdon station with its access to three of London's main airports has possibly become the capital's most important railway hub.

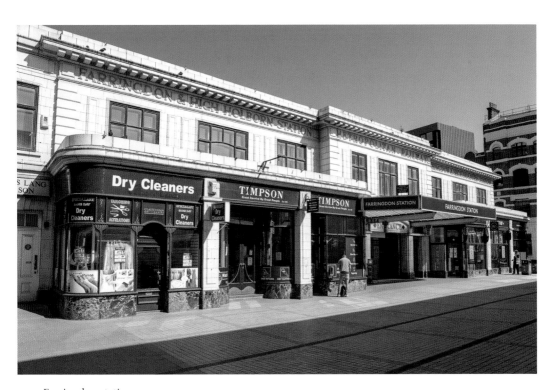

Farringdon station.

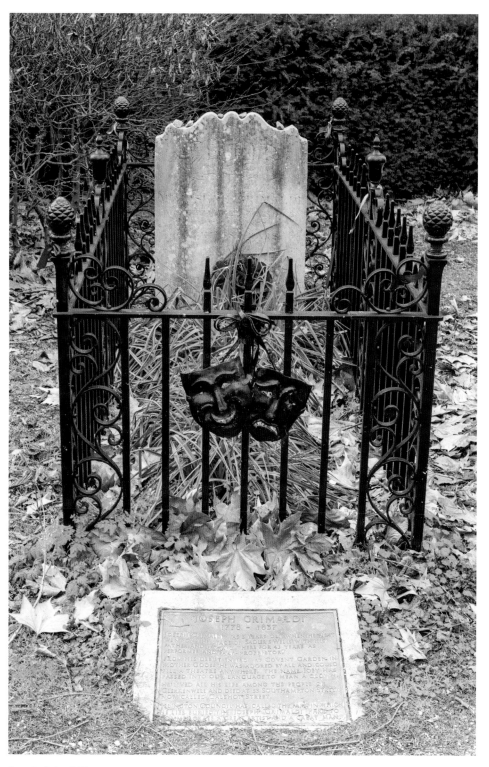

Joseph Grimaldi's grave.

Nowadays the district is remarkably well served by the tube, overground and bus network and probably why so many visitors come here to enjoy its enormous range of pubs, bars, nightclubs, cinemas and theatres. Interestingly, Islington and Clerkenwell have always been great providers of entertainment and were home to some of London's very first theatres in the late sixteenth and early seventeenth centuries. Many spa resorts and pleasure gardens opened here from the late seventeenth century and when their popularity waned in the Victorian era they were replaced, this time by the music hall that took Islington by storm. The dawning of the twentieth century saw a new art form arrive – film – and Islington proved itself to be right at the forefront of the new cinematic age, its name swiftly becoming synonymous with not only cinemas but also celebrated film studios such as Gainsborough beside the Regent's Canal, and Highbury in Highbury New Park.

There are so many different themes to discover about this small but ancient part of London and I hope that the following chapters will give you an insight into its many hidden secrets and inspire you to explore the area and discover more. Nearly every building and street is full of history and has its own story to tell. Islington and Clerkenwell's past has so many interesting threads and in many respects is a potted history of London, of which it is such a tiny part today.

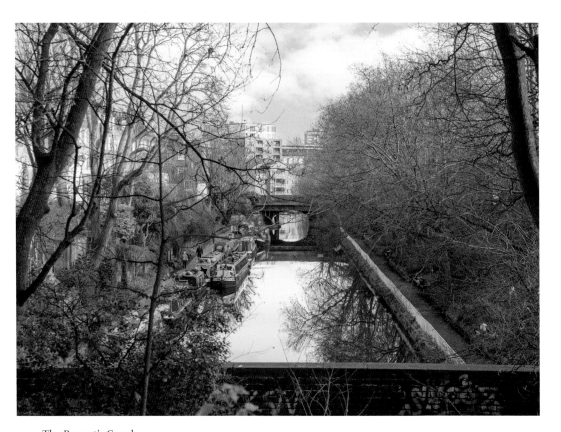

The Regent's Canal.

Note

Throughout this book you will see reference to buildings designated by English Heritage as Grade I, II* and II listed status. Deemed to be of national architectural and historic significance, these buildings are protected and alterations to them can only be made after listing consent has been granted.

DID YOU KNOW?

1. During the early Middle Ages Islington was forested and that wild bears and bulls roamed, and hogs foraged here. It was an area of rich arable land and local inhabitants were self-sufficient.

2. The father of clowns Joey Grimaldi first performed on the stage at Sadler's Wells Theatre at the age of three. It was to be the start of his long and successful career. When he died in 1837 his body was laid to rest in the burial grounds of the former St James's Anglican chapel on Pentonville Road (now renamed Joseph Grimaldi Park). His grave is easy to locate – encased by iron railings and decorated with theatrical masks.

3. London's and the world's very first underground railway, the Metropolitan Railway, opened in January 1863 at Farringdon. More than 600 passengers travelled its 3.5-mile route between Paddington and Farringdon on the day it opened and were then treated to a banquet at the station in celebration of the outstanding feat of engineering.

1. Monastic and Religious Houses

From the twelfth century Clerkenwell was dominated by its monastic settlements that were established here as a result of the area's abundance of natural springs and easy access to the River Fleet, one of the major tributaries of the Thames. Each of these holy communities was extremely affluent and endowed with large tracts of land by wealthy benefactors. The Priory of St Mary and the Priory of St John of Jerusalem were built

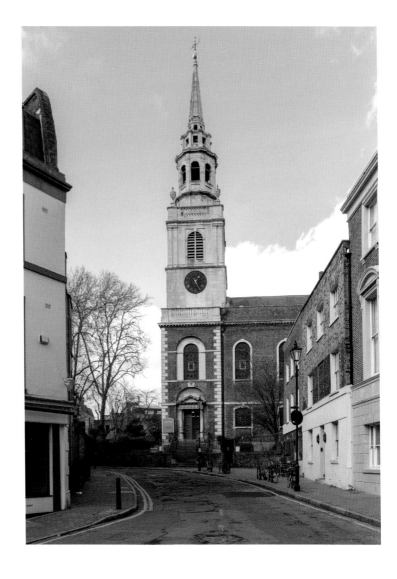

St James's Church,
Clerkenwell Green.

almost side by side in the vicinity of today's Clerkenwell Green and founded in the early twelfth century by Jordan de Briset, a Norman knight. The former was home to about twenty Augustinian nuns along with their servants and lay helpers and they enjoyed a communal life that was separate from the world at large, although they did care for those in need and were involved in missionary work too. Many of their number were the daughters of rich merchants and due to donations of money and land from their families the Augustinian community of nuns became the twelfth richest in the country by the time of the Dissolution of the Monasteries in the 1530s. The nunnery was located right beside the Clerk's Well and extended over 14 acres on which several windmills and a watermill were sited.

Close by, the Priory of St John of Jerusalem was the London headquarters of a religious and military order, the Knights Hospitaller, set up to defend Christianity in the Holy Land. The knights were monks (and noblemen) who had taken vows of poverty, chastity and obedience and were trained in nursing and the martial arts. They bore responsibility for providing safe escort to the Christian pilgrims visiting sacred sites and were also charged with caring for the sick and poor. The order, established at the time of the First Crusade in 1099, was recognised by the Pope in the early twelfth century and in time it became an extremely powerful body. With its large collection of buildings, its armoury, orchards,

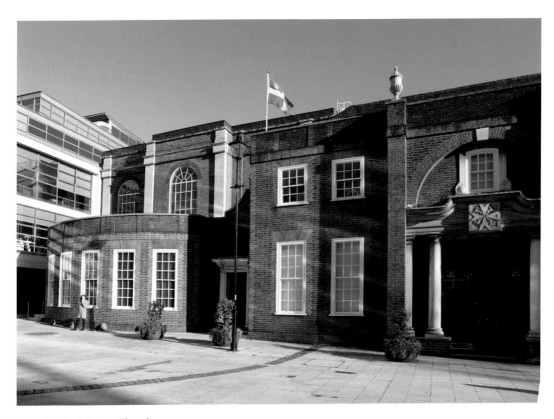

St John's Priory Church.

brewery and treasury the Priory's site in Clerkenwell reflected its important status and the order's leader, the Prior of St John, held one of the highest offices in the land, that of Chief Baron of England. In the fourteenth century he also functioned as Chancellor of the Realm. Unfortunately for him the Prior in office in 1381, Robert Hales, was beheaded by rebels protesting against the unpopular poll tax in the Peasants' Revolt led by Wat Tyler. During the thirteenth and fourteenth centuries the priory was considered with even greater esteem as it provided accommodation for royal personages, as well as pilgrims. King John was known to have stayed at the priory in 1212, while later in the century Prince Edward (later Edward I) and his wife, Eleanor of Castile, received great hospitality from the monks when they lodged at the priory estate. A grand and stately gatehouse, constructed of Kentish ragstone that gave the priory the appearance of a palace, was added in 1504 by the then Prior, Sir Thomas Docwra. It is now the only remaining Tudor building still standing but it gives visitors an idea of how imposing and majestic the priory must have appeared in its heyday. The order's original twelfth-century church was

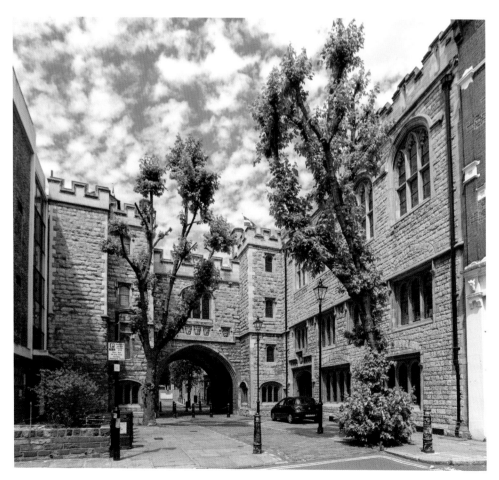

St John's Gate.

modelled on the Church of Holy Sepulchre in Jerusalem but has long since disappeared and today is marked outside the Grand Priory Church in St John's Square by a semi-circle of black stones denoting where the circular nave of the church once stood. The early church was greatly damaged in the mid-sixteenth century and again during the Second World War and was largely rebuilt by Lord Mottistone in the late 1950s. However, its magnificent twelfth-century Norman crypt miraculously managed to survive devastation and is one of a handful of such buildings that remain in the country today.

A third Order of Carthusian monks established itself in the area in 1371 founded by Sir Walter Manny, a senior advisor to Edward III. Their monastery was known as the Charterhouse and was where monks lived a very solitary existence only talking to their brethren on Sundays or Feast Days. The rest of the week was spent alone, each monk in his own separate cell that consisted of a bedroom a prayer room, day room and a private garden. The cells were placed around a garden and there were further buildings in the priory's grounds that housed the lay brothers who looked after the community's needs. The monks themselves spent their days in silence, studying, eating, praying and in contemplation. It was a very disciplined life where no meat was eaten and fasting regularly observed.

All three religious settlements were ultimately closed during the religious tumult of the 1530s when Henry VIII set up the Church of England and dissolved all the monasteries. Their buildings and lands were either seized for the Crown, some were demolished and

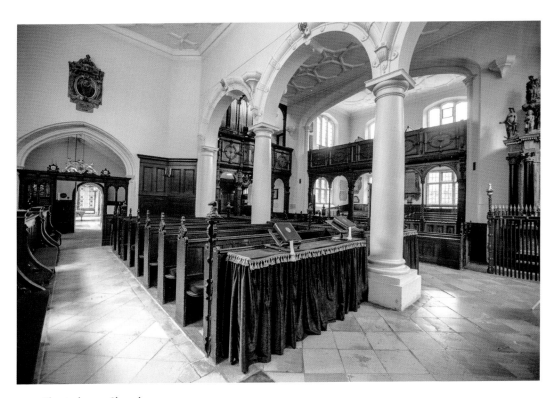

Charterhouse Chapel.

others were given to favourites of the king. Subsequently, the nunnery church of St Mary became a parish church and took a second dedication to St James, the patron saint of travellers, the name by which it is known today. The church of the Priory of the Order of St John after its closure in 1540 became a private chapel, a Presbyterian church, a parish church and finally opened as the Grand Priory Church in 1931. The priory's gatehouse was later used as a repository for Henry VIII's hunting equipment and marquees, then as the office of the Master of the Revels (known to have licenced some of Shakespeare's plays), then as a coffee house, a publishing house for the *Gentleman's Magazine*, a tavern and finally as a parish Watch House. By the mid-nineteenth century it had become quite dilapidated but was given a new lease of life when Queen Victoria bestowed a charter upon it establishing the Venerable Order of St John of Jerusalem and the building was returned to the order once again. No longer a Catholic church, the Grand Priory Church of St John is now mainly used for investitures and services of the order.

Following the Dissolution of the Monasteries Charterhouse's buildings were largely destroyed but its new owner, Sir Edward North, used many of its stones in the construction of his new grand mansion. By 1611 the house had been sold on to one of the wealthiest merchants in the land, Thomas Sutton, who then transformed it into a school for forty boys and an almshouse for eighty poor male pensioners. More than 150 years later the school (with alumni John Wesley, William Makepeace Thackeray and Robert Baden-Powell amongst its number) moved to Surrey leaving only the elderly gentleman at Charterhouse. The buildings continue to be occupied by the pensioners but since 2018 there are both male and female residents, and all are addressed as 'Brothers' in recognition of Charterhouse's religious past.

Walking around Islington you find an enormous variety of churches and chapels, some that have existed on their sites for hundreds of years, although the great majority date to the nineteenth century. Several are the work of famous architects such as Nicholas Hawksmoor and Sir Charles Barry while others were designed by local architects of the day. There are churches here of every denomination – Anglican, Roman Catholic, Methodist, Unitarian and Congregational – and Bunhill Fields on the City Road is a designated Nononformist burial site where the bodies of John Wesley's mother, the artist William Blake and authors Daniel Defoe and John Bunyan are interred.

With a massive increase in London's population in the early 1700s an Act of Parliament was passed to create fifty new churches to serve the growing numbers now residing in the capital. St Luke's, Old Street, was conceived as one of these proposed churches. Building work was completed by the early 1730s but being one of the last in the group to be built, money was short and this subsequently affected the quality of build. From the time it opened St Luke's suffered from major subsidence (the area previously was marsh land) and eventually closed as a church in 1959. After a major restoration of the building in the early 2000s the church is now home to the London Symphony Orchestra's (LSOs) music education centre, and the beauty of the Grade I listed baroque church and landmark steeple, the genius of its designers Nicholas Hawksmoor and John James, can be appreciated once again. The church has marvellous acoustics, and the LSO uses it for rehearsal and recording and it is regularly a concert and recital venue too.

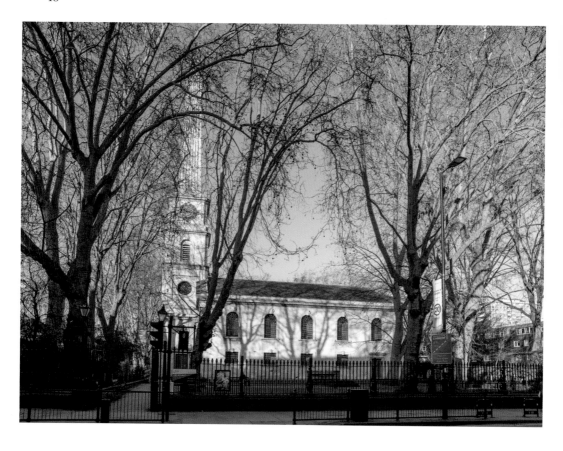

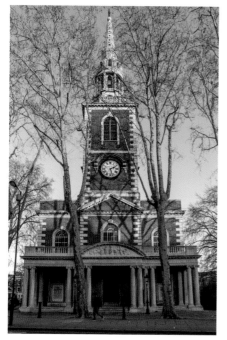

Above: St Luke's Church, Old Street.

Left: St Mary's Parish Church, Upper Street.

It is easy to identify St Mary's Parish Church in Upper Street where the Wesley brothers preached in the early eighteenth century, due to its warm red-brick exterior, tall imposing spire and its handsome portico. The present building dates to 1751 but it is thought that there has possibly been a church on the site since Anglo-Saxon times. Severely damaged by a bomb in 1940 St Mary's was rebuilt and opened once again in 1956. It is a definite beacon along Upper Street today, and highly visible from vantage points all around the district. Interestingly, two twentieth-century curates of the church, Donald Coggan (1909–2000) and George Carey (b. 1935), went on to become Archbishops of Canterbury serving between 1974 and 1981 and 1991 and 2002, respectively.

Although Wesley's Chapel on the City Road was built less than forty years after St Mary's Parish Church, it is markedly different in style. The chapel, the 'Mother Church of World Methodism', is a simple and rather unassuming red-brick building designed by George Dance the Younger and described by John Wesley himself as 'perfectly neat, but not fine'. John Wesley's tomb sits in the back garden and a constant flow of Methodist visitors from around the world come here to pay homage to their great leader. Former Prime Minister Baroness Margaret Thatcher was a regular congregant of the chapel and was married to her husband Denis here in December 1951 and both their children were christened here.

Perhaps one of the most unexpected buildings on the Clerkenwell Road is St Peter's Italian Church. Erected in 1863, it was built not only for the Italian Catholic community but for all practising the Catholic faith, whatever their nationality and living or working in the area. When St Peter's was completed, it was the only church in Britain to be built in the Roman Basilica style. From its entrance on the Clerkenwell Road the church appears tall and narrow leading one to think that the interior will be similarly proportioned.

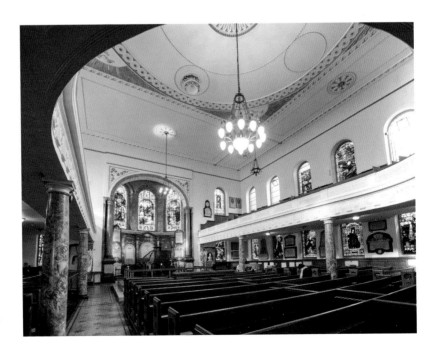

Wesley's Chapel, City Road.

However, when one steps inside the building this assumption is entirely dispelled for the church is a truly wide and cavernous high-ceilinged space, full of painted ceilings and striking frescoes. On account of its excellent acoustics St Peter's has always had a strong musical tradition and has been a popular venue for concerts throughout its existence. The internationally renowned tenors Enrico Caruso and Beniamino Gigli both performed within the church to huge audiences and were met with much acclaim. Before entering the very beautiful Grade II listed church stop for a moment beside the far wall beneath the arched loggia to look at the poignant sculpture relief. The work of the artist Mancini, the relief commemorates the loss of many Italian internee passengers when the *Arandora Star* sank in 1940 during the Second World War on its way to Canada.

Close by in Exmouth Market is the Church of Our Most Holy Redeemer, a building that also has an Italian association. Nestled between shops and housing, it has the most stunning campanile and was designed by the English church architect John Dando Sedding, who based it on Brunelleschi's Church of Santo Spirito in Florence. Services here are conducted in the Anglo-Catholic tradition and the interior of the church is renowned both for its magnificent freestanding Baldacchino high altar and for its Willis organ standing on the gallery at the rear of the church. Our Most Holy Redeemer church has a strong musical tradition and is the frequent venue for musical recitals and concerts, especially choral music.

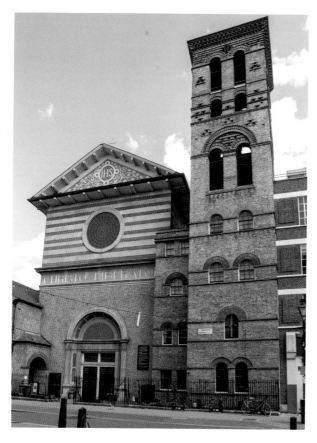

Church of the Holy Redeemer, Exmouth Market.

A third Islington church associated with music is the Union Chapel on Compton Terrace. It was built in the 1870s by the architect James Cubitt for congregants from all Christian denominations. He created a vast column-free octagonal church that is nowadays Grade I listed and famous for its especially magnificent acoustics. One of the most outstanding Nonconformist churches of the Victorian age it has a dual role today –

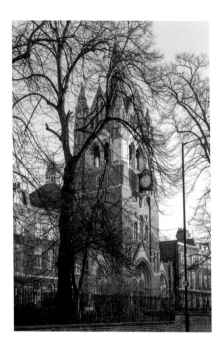

Right: Union Chapel.

Below: Interior of Union Chapel.

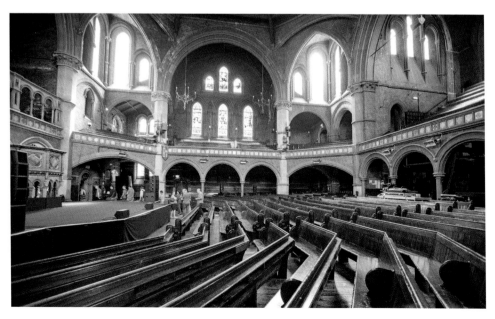

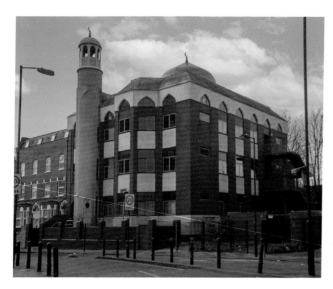

North London Mosque, Finsbury Park.

a working church and an award-winning venue that hires out its space for gigs and live musical performances. It also runs The Margins Project, helping and supporting the homeless and vulnerable in society.

Naturally with such a diverse population there are many buildings of other faiths within the borough too. Hindu temples, Angel's Chabad Lubavitch Synagogue, as well as the large and well-established North London Mosque in Finsbury Park. It is impossible to list all the different religious houses that exist today, but what is fascinating is the range of these buildings, their decoration and size: from tiny Baptist chapels and vast Georgian churches to those with iconic towers and spires and other churches filled with magnificent Italian Renaissance wall paintings. Although the medieval monasteries may have long since gone, it is clear that religion and religious buildings still play an important part in Islington and Clerkenwell today.

DID YOU KNOW?

1. William Weston, the last Prior of the Order of St John, is said to have died of a broken heart the day the priory was finally dissolved in 1540. It was the last religious building to be closed as a result of the Suppression of Religious Houses Act 1536.

2. The Prior of Charterhouse, John Houghton, was executed for not accepting Henry VIII as head of the Church of England and as a warning to others who opposed the king his severed arm was nailed to a post of the monastery buildings.

3. St Luke's was known as 'lousy Luke's' as locals thought that the creature on the brass weathervane on top of the spire was a louse, not a dragon.

2. Immigrants and Craftsmen

Since the Romans invaded the country two thousand years ago, Britain has welcomed successive groups of migrants, many of whom have chosen not only to settle here but have massively enriched our culture with their own customs, traditions and work practices. For hundreds of years the villages of Islington and Clerkenwell, so close to the heart of London, have been an ideal haven for newcomers. The location of Clerkenwell in particular has always proved to be attractive to immigrant workers as, not being members of a recognised guild, they were unable to gain employment in the City of London. Throughout the Middle Ages only those completing a seven-year apprenticeship were allowed to practise their trades within the City and work was monitored by powerful guilds. These bodies set the industry's standards and monitored the quality of finished goods and work. They prevented unlimited competition and imposed fines and other penalties upon their members if the products or services supplied were sub-standard. This resulted in a highly controlled system that dominated London's employment scene and only permitted the practice of certain trades and crafts in its confines.

From the late seventeenth century workers from all over the UK and many from overseas settled in Clerkenwell, each group bringing its own crafts and skills, contributing to the local economy. The Huguenots were one of the first groups to make their mark on the area in the late 1600s, fleeing from France following religious persecution brought on by the revocation of the Edict of Nantes. With skills in watch and clock making, silk weaving, printing and bookbinding, in banking and commerce as well as the manufacture of jewellery, precision tools, guns and scientific instruments they were well accepted in the area. Once established many worked from home in small backyard workshops or in studios at the top of their houses. If you walk around Clerkenwell's streets today, you may well notice how many windows fill the upper storeys of the terraced houses. It was up in the attics that so many of the Huguenot silk weavers would work, taking advantage of the light streaming in through the glass.

Right up until the twentieth century Clerkenwell's streets were jam-packed with small specialist engineering works and workshops largely associated with the printing and engraving trades and watchmaking. It became the manufacturing hub for clocks and watches in London and many of the local streets were entirely devoted to different aspects of the trade such as clock faces, gear wheels, pendulums, springs and clock hands. These small businesses continued their specialist crafts even in the face of great competition from abroad and long after the industry moved from bespoke to automated products. Unusually, in the mid-nineteenth century, one of Clerkenwell's most successful clock companies, John Smith & Sons, employed an entirely different working strategy. Their large factory in St John Square worked more on the lines of mass production where all the clock making processes were kept under one roof. This was novel for the time and

Huguenot houses with attic windows, Britton Street.

quickly recognised to be extremely efficient. The firm remained in business for over two hundred years and only closed its Clerkenwell site in the late 1980s, although by now its emphasis had changed from clock making to metals supply.

Throughout the 1800s horology was a major industry in Clerkenwell and so it is unsurprising that when the Northampton Institute (the predecessor to City University London) was set up in 1894 horology was amongst its courses on offer. For almost a hundred years the streets and square beside the Institute (Northampton Square) were associated with horologists. All manner of clocks – domestic, turret, long clocks, musical, and astronomical – were manufactured and sold throughout the globe. Even though the Huguenots had brought their valuable skills to the area, established British clockmakers such as Thwaites and Reed (said to the be oldest in the world) had been operating in Clerkenwell since the late 1600s.

Nowadays there is little evidence left of the businesses and workshops that once dominated the local streets, but several small quality watch repair shops still exist in and around the Goswell Road and St John Street. The significance of clock and watchmaking in Clerkenwell is remembered too on the façade of Watchmaker Court (a modern office building) in St John's Lane; here, you can see plaques that commemorate eight local clock makers including the celebrated Thomas Tompion and Christopher Pinchbeck.

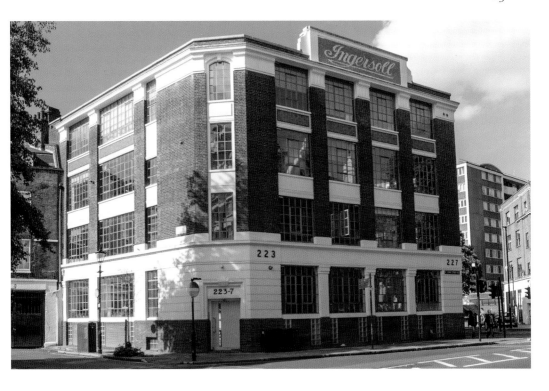

Above: Ingersoll Watch Factory, St John Street.

Right: J. Smith and Sons street clock.

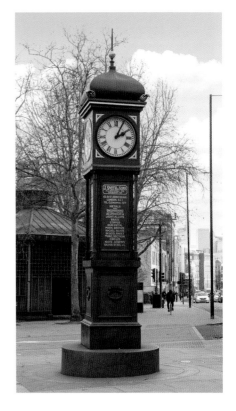

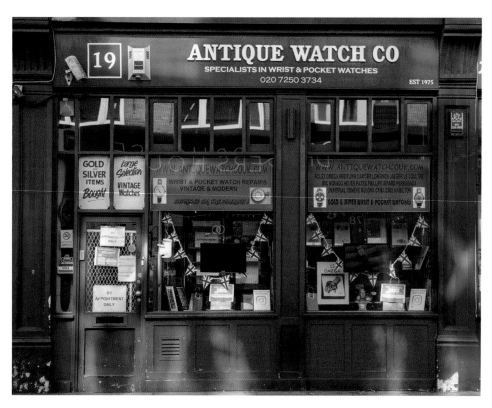

Antique Watch Co., Clerkenwell Road.

Watchmaker Court, St John's Lane.

Shops in Hatton Garden.

The Huguenot influence has not entirely disappeared, and it is no coincidence that Hatton Garden, London's most famous jewellery district, is located on Clerkenwell's western border. Running between Clerkenwell Road and High Holborn, Hatton Garden is internationally recognised for the quality and style of its jewellery, its luxury watches, gold, platinum, silver and diamonds. Nowadays, the Goldsmiths' Centre close by in Britton Street sponsors and trains students in the art of gold and silver smithing and provides workshop space and courses reaching out to apprentices, as well as well-established practitioners in the industry. In fact, the entire area of Clerkenwell is regarded as a major centre for the creative arts and is filled with all manner of design and architectural workplaces (see Chapter Architecture and Design).

The Irish followed the French and arrived in London in the early eighteenth century when they initially took on work as agricultural labourers. After Ireland's devastating potato famine of the 1840s many more of their countrymen left to find work in London, attracted by the capital's economic expansion and growth. By the mid-1850s Islington and Finsbury's Irish population numbered 6,000, the vast majority of whom were employed as labourers and navigators building many new roads, canals and railways and earning them the nickname, 'navvies'. These early migrants settled in and around the poor, typically working-class areas at the Angel and City Road, as well as Archway and Upper Holloway, and were often resented by the resident population who believed that the newcomers were taking away their employment and housing. Nonetheless, many Irish continued to arrive, their numbers fluctuating over the years. There was another influx after the Second World War (1939–45) when many of them took jobs in the construction industry and health service, of great benefit to post-war London. The Irish population

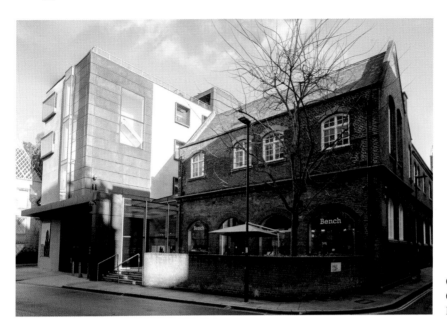

Goldsmiths'
Centre,
Britton Street.

actually doubled in the borough in the 1950s, went into decline and then had a resurgence in the 1980s when the new settlers largely came from the professional classes.

There is no doubt that over the years the borough has gained much from its Irish residents and Irish music in particular is still extremely popular in local pubs. Islington's Irish community has always consisted of workers from every walk of life and there are a number of famous residents – the writers Oliver Goldsmith and Oscar Wilde, political figures such as Michael Collins, the creator of the Royal Ballet company, Ninette de Valois and the Children's Drama School founder Anna Scher.

The Irish were succeeded by the Italians who gravitated to Clerkenwell following the Napoleonic Wars (1799–1815). The first to arrive were political refugees and revolutionaries such as Garibaldi, Mazzini and Cavour, men of stature in their country. They were then joined by skilled craftsmen – jewellers, brick and tile makers, mosaicists and instrument makers – as well as roaming musicians from central and northern Italy. These early immigrants came alone but in time, once they had established themselves, they brought over their wives, girlfriends and children. Later, groups of unskilled and poor workers from the south of Italy found their way to the area too, happy to take on seasonal work as accordionists, organ grinders, knife sharpeners and ice-cream sellers and then as the weather cooled down turned their hands to construction work or became street food sellers offering hot chestnuts or potatoes. The majority of these newcomers set up home in and around today's Clerkenwell Road in Saffron Hill, Leather Lane, Ray Street, Warner Street, Herbal Hill, Back Hill and Eyre Street Hill where, although the housing was horribly overcrowded (families were often forced to share one room), accommodation was cheap. There is no evidence now of the tenement buildings they lived in, but Chiappa & Co.'s Organ Builders' former premises can still be seen at the bottom of Eyre Street Hill. As increasing numbers of Italians arrived in the district; their

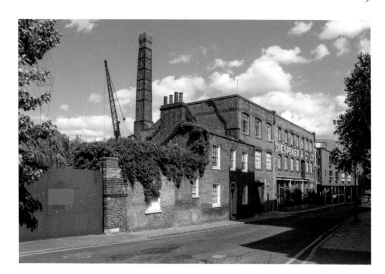

Diespeker Wharf,
Graham Street.

numbers swelled from around 1,500 in the mid-1800s to 10,000 by 1901. So, during much of Queen Victoria's reign a tenth of London's entire Italian community were residents of Clerkenwell and this was the reason why this quarter was soon referred to as 'Little Italy'.

Gradually as the community became more established it set up its own schools, shops, a working men's club, a hospital in Queen's Square in Holborn, and its very own church, Chiesa Italiana di San Pietro (St Peter's Italian Church). The latter, still very much a landmark on the Clerkenwell Road, was built in the 1860s to be both the religious and spiritual centre for London's Italian population. Its Irish designer, John Miller Bryson, worked from plans drawn by Francesco Gualandi of Bologna and the quite magnificent interior decoration of St Peter's is largely the work of artisans brought over from Italy.

Today, Clerkenwell's Italian resident population is much reduced, yet St Peter's and Little Italy remain a strong focus of Italian life. Every summer, an exciting festival takes

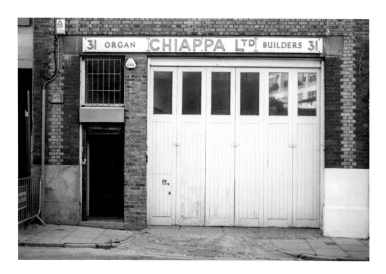

Chiappa organ works,
Eyre St Hill.

St Peter's Italian Church, Clerkenwell Road.

place in the streets surrounding the church celebrating the feast of Our Lady of Mount Carmel (Fiesta di Madonna del Carmine). At this time the roads are closed to vehicles allowing a procession of colourful religious floats to pass by. It is also where stalls selling enticing Italian delicacies are set up, popular with both the local population and London's Italian community.

Nowadays, the borough is home to people from all over the world and over a third have ethnic backgrounds. Many professionals choose to live here because of its proximity to the City of London where they work, but Old Street and Clerkenwell with their 'Silicon Roundabout' IT and design workforces naturally attract workers from every corner of the globe.

DID YOU KNOW?

1. It is estimated that following the creation of the National Health Service (NHS) in 1948 more than 85 per cent of nurses at the Whittington Hospital came from Ireland.

2. Thwaites and Reed's magnificent eighteenth-century turret clock at Horse Guard's Parade is still a working clock. It was the company's first commission and took almost thirty years to construct.

3. The annual July Feast of Our Lady of Mount Carmel has been a most important date in the calendar of the Italian Church of St Peter's since it opened in the 1860s. Moreover, its colourful procession is believed to be the first Roman Catholic celebration to have taken place in London's streets since the time of the Reformation in the 1530s.

3. Water, Water Everywhere!

From Waterways, Spa Resorts and Pleasure Gardens to the Production of Beer and Gin

Islington and Clerkenwell's fortunes have always been greatly associated with water, both natural and man-made. Certainly, in the Middle Ages, it was the presence of the clear, clean waters of the river Fleet, the 'River of Wells', that made Clerkenwell so attractive and contributed to the area's prosperity and growth, encouraging three monastic communities to settle there. William Fitzstephen, cleric and administrator to Archbishop Thomas Becket, wrote in 1174 that 'There are also about London ... excellent suburban springs, with sweet, wholesome and clear water that flows rippling over the bright stone; among which Holy Well, Clerkenwell ... are held to be of most note.' For at least 300 years the Worshipful Company of Parish Clerks performed religious miracle and mystery

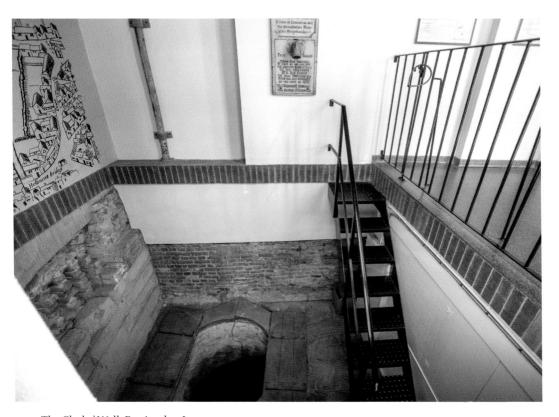

The Clerks' Well, Farringdon Lane.

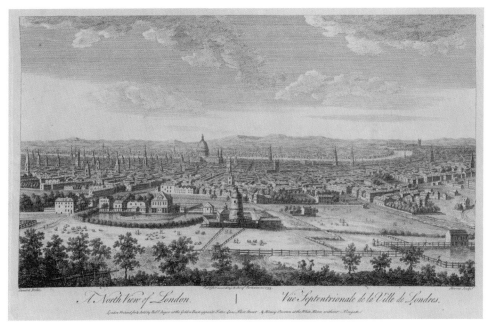

A north view of London with the New River Head ponds in the foreground. (Courtesy of the British Library)

plays on the banks of the Fleet, an entertainment so popular that even kings and queens attended the spectacles. The plays took place just beside the well situated in St Mary's Nunnery and it is because of the Parish Clerks' association with the area that this well ultimately became known as the Clerks' Well. From the twelfth to sixteenth centuries the well provided a supply of fresh water to the nuns but when St Mary's was forced to close in the 1530s the local population was granted access to the well's clean water. The custom lasted until the middle of the nineteenth century when the local vestry, then the Clerks' Well's landowner, shut the well due to its polluted waters. It then appears to have been forgotten until excavations were in progress in the basement of No. 16 Farringdon Lane in 1924. In the course of work, the well was rediscovered and this led to the local authority, Finsbury Borough Council (the present Borough of Islington), taking over the lease of the building. The Clerks' Well was subsequently restored and later a viewing area was added, making the site accessible to visitors. Nowadays, Clerkenwell and Islington tour guides run walks of the area that include a visit to the well; information about the walk and their programme can be found on www.islingtonguidedtours.com.

Breweries and Distilleries

The presence of so much water was also the reason why Clerkenwell became such a magnet for the brewing and distillery industries. From as early as the sixteenth century it is known Thomas Crosse purchased water from the Clerk's Well to use in his brewery and by the 1700s many more brewing businesses were thriving across the district. The Cannon Brewery Co. Ltd was established on St John Street in 1720, the Griffin Brewery

Booth's Gin Frieze,
Britton Street.

(later Reid and Co.) on the Clerkenwell Road opened in 1763 and Whitbread's brewery on Chiswell Street was built in 1750. The latter was such an enormous enterprise that it received royal visits from George III, Elizabeth II and the Queen Mother in its two hundred-and-twenty-five-year history.

Gin distilleries too were a major feature of the area from early in the eighteenth century when London was in the midst of a major gin craze. Gin was initially made in people's kitchens and sold from their homes, as well as in outlets such as barbers, grocer shops, brothels and even from street barrows. It was made using low quality grain and sometimes flavoured with turpentine and was an exceedingly alcoholic, cheap and entirely addictive refreshment. As such it gave its customers a much-needed 'fix' and was a great alternative to the often polluted and unsanitary drinking water. The horrendous effects of this drinking addiction on the population were satirised in an engraving by the artist William Hogarth, 'Gin Lane', which highlighted its drawbacks showing people totally drunk, others carrying out criminal acts and the resident population generally caught up in vice and debauchery. Ultimately, Parliament saw fit to pass a series of Acts culminating in the Gin Act of 1751 which compelled distillers selling gin to become licensed, thus limiting the outlets for gin sales. The result of this legislation in the following years was for gin to be manufactured on a much larger scale by reputable distillers such as Langdale's, Nicholson's, Booth's and Tanqueray Gordon. They all had premises in and around Clerkenwell – and traded in the area from the eighteenth century; the last business, Gordon's, ceased trading on the Goswell Road in 1984. Today its former premises houses an enormous data centre. Although many of Clerkenwell's former distillery and brewery buildings remain in the district, it is people rather than barrels or gin bottles that reside there today!

New River

In the early 1600s with London's population on the increase there was an urgent need for water in the capital. Many ideas had already been considered on how to supplement

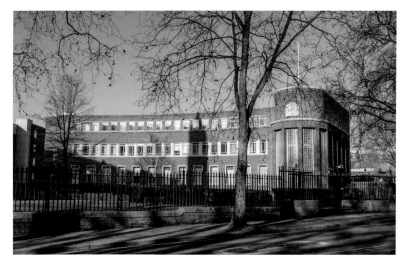

Above: Former New River Head Offices, Rosebery Avenue.

Left: Former New River Laboratory Building, Rosebery Avenue.

London's water supply and although attempts had already been made to draw water from the River Thames, this had not solved the problem. So, when Edmund Colthurst devised a scheme to bring clean water from springs around Ware in Hertfordshire, he was given the go-ahead and work began in 1604 on building a 38-mile course from the area to Clerkenwell. Despite being called the New River, it was in fact a man-made canal, 10 feet (3 metres) wide and 4 feet (1.2 metres) deep. It was an enormous project, and many labourers and carpenters were required to build the channel (they received 4*d* and 6.5*d*

Source of the new river, Amwell, Hertforshire.

each per day). It was hardly surprising then that the enterprise ran into money problems. Fortunately, Hugh Myddelton (1560–1631), a wealthy Welsh goldsmith and MP, came to Colthurst's rescue and took over the development. Myddelton too ran into financial difficulties but with help from the king, James I, the waterway was finally completed in 1613, and the king showed his gratitude to Myddelton by bestowing a baronetcy and knighthood upon him.

The New River terminus was a circular 200-foot water basin beside the New River Company's headquarters, close by today's Sadler's Wells Theatre in Rosebery Avenue. In fact, the basin was made up of two ponds, the inner pond discharging water into the outer pond from where water was distributed through hollowed elm pipes to homes in the capital. Even though the original water building disappeared a long time ago there are remnants to be seen of its windmill and eighteenth-century engine and pump house buildings beside Amwell Street, and its upper reservoir still sits in the centre of Claremont Square near Pentonville Road. The twentieth-century New River Head headquarters and laboratory buildings on Rosebery Avenue have been transformed in recent years from offices into luxury apartments. Interestingly, four centuries since it was constructed water continues to flow along the New River's course. Although much of it now is piped underground, it is still a vital part of London's water system, supplying drinking water to 700,000 Londoners.

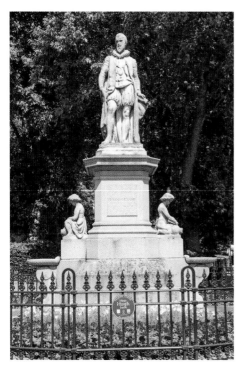

Left: Statue of Sir Hugh Myddleton, Islington Green.

Below: The New River Head, Clerkenwell. (Courtesy of the Wellcome Collection)

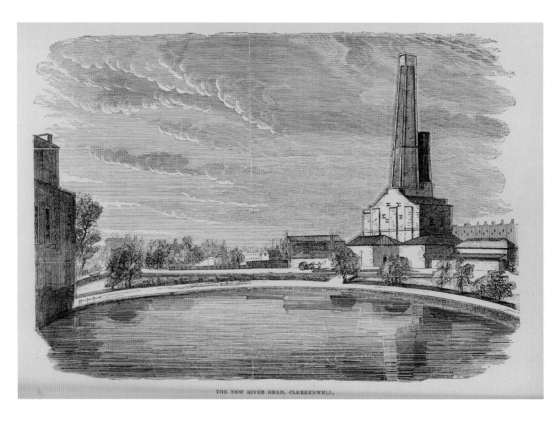

THE NEW RIVER HEAD, CLERKENWELL.

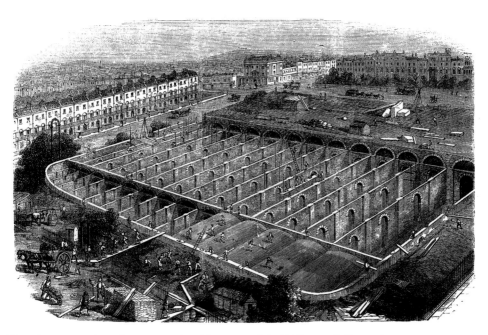

New river reservoir under construction. (Courtesy of the Wellcome Collection)

A stretch of the New River in Canonbury today.

Spa Resorts and Pleasure Gardens

Towards the end of the seventeenth century Clerkenwell and Islington's many springs and wells were a focus for entertainment too. This was the heyday of British spa resorts, with towns and villages like Bath, Cheltenham, Hampstead and Tunbridge Wells packed full of summer visitors taking the waters, attending the baths and enjoying a range of entertainments. Islington Spa located opposite Sadler's Wells (the location today of the Spa Green Housing Estate) was frequently referred to as New Tunbridge Wells as its chalybeate spring water was supposed to be a similar composition and quality to that of Tunbridge Wells, then considered to be the best medicinal spring resort in the country. Islington had two main resorts near to the New River terminus: the Islington Spa and Sadler's Wells. Despite their proximity they were not in direct competition as they attracted different customers. Sadler's Wells was more of a music house while Islington Spa was the more fashionable resort, a genteel venue famed for its lime walks and arbours, its coffee house, dancing and gambling rooms. Both spas claimed that their waters contained curative properties for a host of maladies ranging from bad skin conditions to stomach and digestion problems and so visitors were persuaded to 'take the waters'. Although apparently unpalatable, the remedy was felt to be worth the endurance in the hope that their illnesses would be cured. Access to the water was free as an inducement for customers to pay for the many entertainments on offer at the spa resort. While the Islington Spa provided fireworks, ballooning, music and freak shows

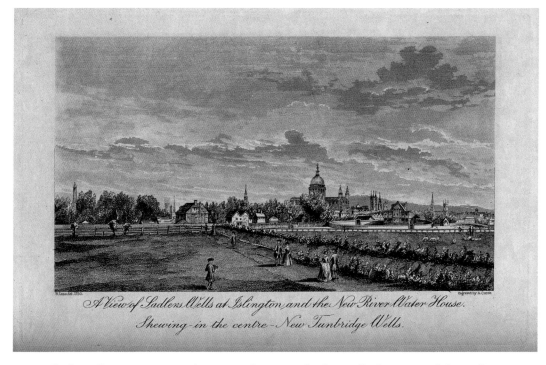

Sadler's Wells, New River Head House and New Tunbridge Wells. (Courtesy of the Wellcome Collection)

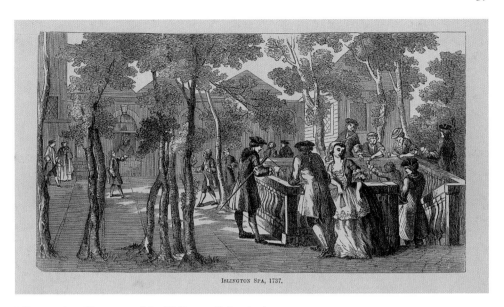

ISLINGTON SPA, 1737.

Islington Spa. (Courtesy of the Wellcome Collection)

the neighbouring Sadler's Wells offered amusements such as rope dancers and jugglers and its clientele was less genteel, consisting of tradesmen, sailors, butchers and strolling damsels. Sadler's Well's reached its peak of popularity in the 1680s and the resort was later replaced by a theatre in the mid-eighteenth century while the Islington Spa stayed in business until 1840. By this time a bowling green and an orrery had been added to the latter but its reputation declined, and its clientele moved on to other pursuits.

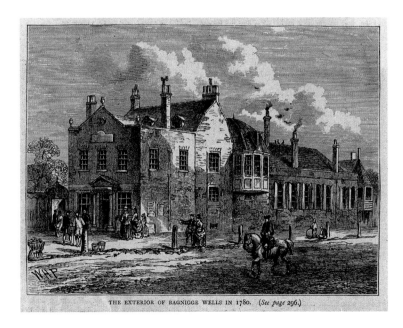

THE EXTERIOR OF BAGNIGGE WELLS IN 1780. *(See page 296.)*

Bagnigge Wells. (Courtesy of the Wellcome Collection)

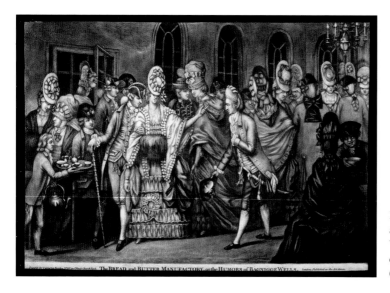

Entertainment at Bagnigge Wells. (Courtesy of the Wellcome Collection)

Bagnigge Wells near to Kings Cross was also highly regarded as a spa but only opened its doors in the mid-eighteenth century some seventy years after the other two resorts. It too offered a great variety of entertainment – singers, acrobats, concerts, bowling, and tightrope acts – but finally closed in the 1840s when its popularity waned.

As the spas began to disappear pleasure gardens took their place across the borough – the most famous being the White Conduit House, Highbury Barn, Belvedere Tavern, Canonbury Tavern Tea Gardens, and Copenhagen House. Set out as vast gardens with walks, they offered refreshments in the form of tea, coffee, ale, hot rolls and cakes, as well as games such as bowls and Dutch-pin, skittles, cricket, and bullbaiting. Several even offered clients fishing, music, fireworks and balloon ascents. People from every walk

Highbury Barn.

of life visited Islington's pleasure gardens throughout the eighteenth and nineteenth centuries. They enjoyed the wide choice of activities available and the diversity of the venues around the district.

Regent's Canal

The Regent's Canal was a major feat of engineering when it was built in 1812–20 and as a new form of transport it rapidly came to dominate Islington's landscape. Joining the Grand Union Canal at Paddington, the canal's route continued through Maida Vale, St John's Wood, Camden Town to Islington and from here on to Limehouse in East London's docklands. Barges filled with coal, timber, sand, gravel, corn, grain, ice, and hay, as well as refuse and waste, brought freight and produce into Islington and within no time the canal's basins were lined with wharves, quays, depots and warehouses. Raw materials were unloaded onto the quays and stored in the warehouses before distribution by horse and wagon around the capital. In fact, the carrying company Pickfords had an enormous presence around the City Road basin in the 1840s, owning both the largest fleet of boats and number of horses at the time. Initially the barges were powered by horses but in time many were replaced by steam tugs, which made the job of the bargemen easier when

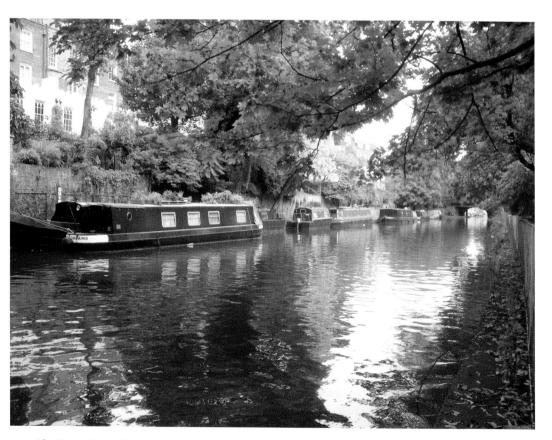

The Regent's Canal.

navigating through the Islington tunnel. Steam power ended the practice of bargemen 'legging it' when they were forced to lie on their backs pushing against the tunnel's roof and sides with their feet to propel the barge forward – a horrid job and physically exhausting. Sadly, the advent of the railways from the middle of the 1800s led to the demise of the Regent's Canal, and although cargo continued to be transported along the waterways into the twentieth century, it became less and less efficient or economic compared to train and road transport. However, the canal has seen a resurgence in the past fifty years and is now extremely popular again, albeit for leisure purposes. It is not uncommon to see pretty-coloured narrow boats floating slowly along the canal passing by Islington's housing and industrial fabric. Boats are available for hire and companies such as Hidden Depths run regular cruises along the Regent's Canal between Camden and Islington.

DID YOU KNOW?

1. New River Walk in Canonbury is the only surviving section of the original New River channel. Nowadays set within public gardens, it is a delightful oasis in Islington and greatly appreciated by local residents. An officer of the New River Company would have been sat in the garden's attractive watch house keeping an eye on visitors, his job to prevent them from bathing, swimming or fishing in the water.

2. The Islington Tunnel of the Regent's Canal is London's longest canal tunnel at around three quarters of a mile in length, and runs between Pentonville and Colebroke Row, close to Upper Street.

3. Islington Spa was the most fashionable venue in the 1730s and was even frequented by George II's daughters, Princesses Amelia and Caroline. Despite the supposedly foul smelling and tasting spa water, as many as 1,600 people a day would come to take the waters here, keen to mingle with the rich and famous and to enjoy the entertainment that included freak shows, dancing, music and firework displays.

4. Architecture and Design

Islington and Clerkenwell are real creative enclaves renowned as being home to dozens of design studios, independent shops and outlets. In particular, the past few decades have seen many of the villages' unique variety of historic buildings be transformed into workshops, studios and showrooms. This emphasis on design is not, however, a new phenomenon but dates to the Industrial Revolution and even earlier when craftsmen and artisans arriving from overseas were forbidden to work in the City of London (see Chapter Immigration and Craftsmen). Many of them thus set up homes and businesses just outside the City's walls in Clerkenwell. Today it is claimed that more than a quarter of all the UK's architect practices are based in London and the great majority of these operate in the borough of Islington, mainly in its southern area around Clerkenwell. The district's streets are awash with all manner of creative businesses, and it has developed into one of the world's most significant design hubs hosting an internationally acclaimed festival, the Clerkenwell Design Week when visitors come to experience exhibitions, showroom events, installations, as well as a series of talks. There are more than 100 contemporary showrooms dotted around this highly artistic quarter and numerous eminent design brands are based here including Vitra, Arper, Cappelini and USM.

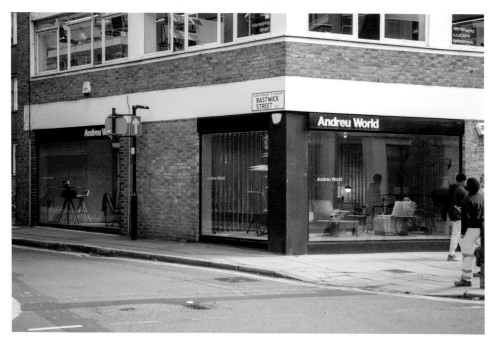

Andreu World showroom, Goswell Road.

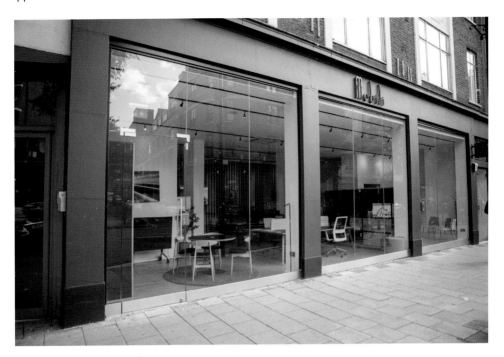

Mobili showroom, Goswell Road.

Walk down any street in the borough of Islington and you will encounter the most striking if not unusual architecture. The area is full of magnificent industrial, civic, secular, and religious buildings, as well as a fine array of residential accommodation dating as far back as the sixteenth century. At every turning, junction, major or minor road you will find something of note whether it be a contemporary glass tower block, an elaborate carved frieze, an ornate Victorian warehouse, or even a disguised ventilation shaft. The crypt of St John's Priory Church is an outstanding example of Norman architecture and one of only very few such buildings that remain in the country today, while the sixteenth-century Canonbury Tower, associated with prominent statesmen of the period (Thomas Cromwell, Henry VIII's Chancellor, and John Spencer, Lord Mayor of London), as well as the eighteenth-century writers Washington Irving and Oliver Goldsmith, is a wonderful illustration of domestic Tudor architecture.

Clerkenwell, lying just outside the City of London's boundary and beside the River Fleet, has been a well-established settlement for over a thousand years. Unsurprisingly, it contains the greatest variety of building styles in the borough. In contrast, Islington (except Upper Street – the main route into London from the north) remained an area of fields and meadows and was largely undeveloped until the 1800s when its population swelled during the Industrial Revolution. The urgent need for housing culminated in the establishment of row upon row of Victorian terraced housing and some very fine Georgian squares, the latter built for the middle classes, impressive and quite varied architecturally. They range dramatically in style: from the highly pointed arched Gothic housing in Lonsdale Square to the classic Greek architecture of Lloyd Square, and then again to the

Lonsdale Square.

Lloyd Square.

more familiar flat-fronted four- to five-storey Georgian terraces of Canonbury Square. Nowadays, both areas have seen many of their buildings repurposed so that warehouses have been converted into loft apartments, churches into recording studios, a mail sorting office into luxury apartments and shops, factories and schools into architectural practices and a town hall into a performing arts centre.

From the early seventeenth century the terminus of the main reservoir of The New River Company and its offices lay adjacent to the site of today's Sadler's Wells Theatre. Although nearly all the original buildings have long since gone, the remains of the New River's windmill and its 1768 engine and pump house can still be seen on Amwell Street and are fine examples of late eighteenth-century industrial architecture. They are currently undergoing restoration and will shortly provide a home for the new Museum of Illustration.

The architecture of the nineteenth century is also exhibited throughout the borough in many of its old industrial and civic buildings. Numerous schools, banks, factories, warehouses, depots, engineering workshops and printing works were established here, and some were almost works of art in themselves. The Victorians certainly knew how to create handsome and often ornate buildings, embellishing them with carved frieze work, statues, patterned bricks, wrought- and cast-iron decorations and railings. Civic buildings too such as Finsbury Town Hall and the clock tower of Caledonian Market

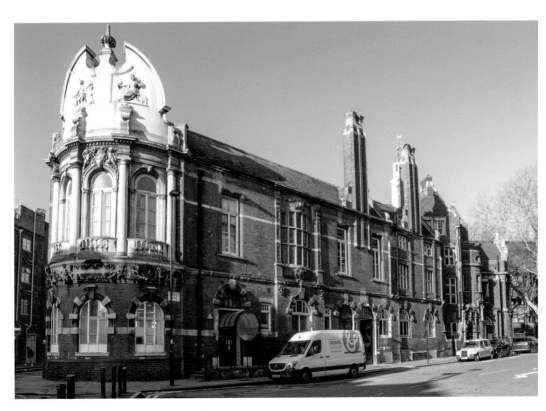

Former Finsbury Town Hall, Rosebery Avenue.

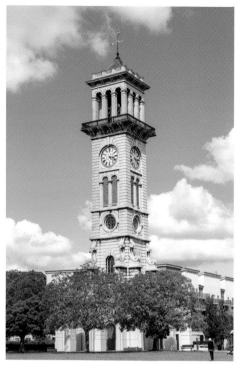 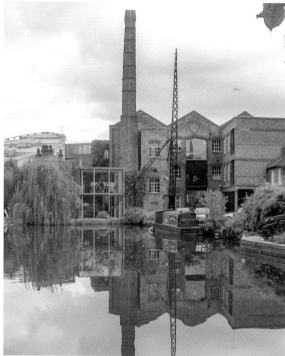

Above left: Caledonian Tower.

Above right: Diespeker Wharf.

were treated to elaborate ornamentation, designed by leading architects of the day. A particularly unexpected treat is to be found on Sekforde Street in the Finsbury Bank for Savings (nowadays converted into a private home) that looks remarkably like an Italian Renaissance palace. Diespeker Wharf on Graham Street is an excellent example of Victorian industrial craftsmanship and design. Nowadays the building is occupied by the architectural practice Pollard Thomas Edwards (PTE), who were responsible for its initial renovation in the 1990s. Built originally as a timber mill, it later became the premises of an Italian terrazzo manufacturer and sitting by the lock at Angel Basin on the Regent's Canal, it is easily identified by its tall chimney, crane and a stunning modern glass extension. Many of its original features have been retained and are still on display within PTEs offices.

The early 1900s saw the erection of buildings such as Islington Central Library in Holloway Road, the Arsenal football stadium in Highbury and the Laboratory Buildings at the New River Head on Rosebery Avenue. The latter were converted into apartments more than twenty years ago and the new Emirates Stadium replaced Arsenal's original grounds in 2006 (which have since been turned into Highbury Square, another private housing development).

In the 1930s the borough benefited from the Russian émigré architect Berthold Lubetkin's work. Together with his Tecton architectural practice he was responsible for

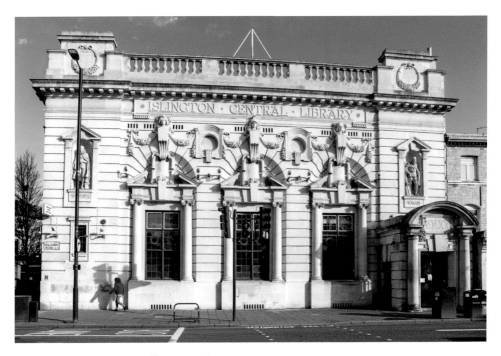

Islington Central Library, Holloway Road.

the 1930s Finsbury Health Centre and post-war residential estates such as Spa Green and Bevin Court. Lubetkin's health centre is still in use today as the Pine Street Medical Practice and has been awarded Grade I listed status in recognition of both its architectural merit and the significance of the pioneering nature of the building's design and purpose. It was the first integrated health centre in North London where patients were given access to a multitude of facilities in one place ranging from treatment rooms and clinics – including one dedicated to tuberculosis, to dental and chiropody services and even a de-lousing station. Working with Finsbury Council Lubetkin and Tecton published the 'Finsbury Plan' long before the foundation of the National Health Service, to improve the health, welfare, and housing amenities for the people living in this deprived and overcrowded district. Hugely successful, Finsbury Health Centre was heralded then (and now) for its progressive vision and was an enormous step forward in the provision of health and social care. Unfortunately, almost a century on the building needs much attention – which is especially costly due to its listed status. However, recent press articles state that the medical practice is about to receive £1.25 million to repair its façade and restore its crumbling fabric – long overdue and hopefully work will begin soon to bring the building back to its original state.

Built for an entirely different purpose but at a similar time is the former Carlton Cinema on Essex Road. Completed in 1930 in the art deco style, it looks a little like an Egyptian temple (a particularly fashionable theme after Howard Carter's discovery of Tutankhamun's tomb in Egypt in the 1920s) and has an unusual façade consisting of columns, lotus flowers, and bud reliefs. Nowadays, it is home to Gracepoint, an events and meeting space, but in its heyday it attracted cinema audiences of up to 2,000 and was a

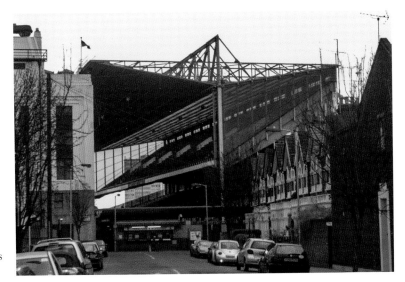

Right: Old
Arsenal
stadium.

Below: Emirates
Stadium.

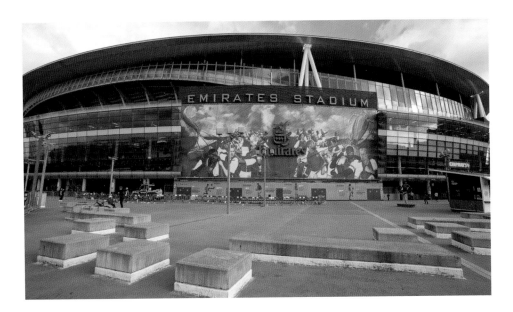

very popular venue. Designed by George Cole, one of the great theatre architects of the day, it is a reminder of how important an entertainment the cinema was in the early part of the twentieth century.

Another 1930s building not to be missed is Florin Court. This is a striking art deco block of flats located in Charterhouse Square that has become familiar to many on account of it being home to the Belgian detective Hercules Poirot, in LWT's television series *Agatha Christie's Poirot*. With its graceful curves and fabulously undulating shape, it is an outstanding example of the streamlined moderne architectural style. It was built as a 'U' by its designer Guy Morgan to enable as many flats as possible to have a view over

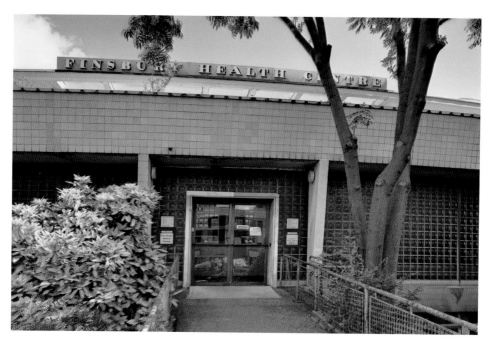

Finsbury Health Centre, Pine Street. (Courtesy of the Wellcome Collection)

Charterhouse Square and its gardens. The building still retains some superb modernist features such as its iron railings, lighting and signage, and the flats remain extremely sought after, selling almost as soon as they come on the market.

Many more new buildings appeared in Islington and Clerkenwell during the twentieth century, and all have left their mark on the area. No. 44 Britton Street is a particular case in point. Designed in the late 1980s by Piers Gough for the broadcaster and journalist Janet Street-Porter CBE, it stands on the corner of Albion Place and bears a great resemblance to the prow of a ship. It has been described by Historic England as 'an extrovert and ostentatious example of Post-Modern domestic architecture' and now carries Grade II listed status. The revamp of Sadler's Wells Theatre by Nicholas Hare Architects (NHA) in the late 1990s has resulted in its exciting new glass and brick Rosebery Avenue façade and is a contemporary theatre to rival many in the West End. Most recently, the southern end of City Road has seen the erection of a plethora of high-rise towers, offering hotel, office and residential accommodation. Old Street (Silicon) roundabout has been transformed and now is a feast of architectural styes ranging from the imposing red-brick early twentieth-century Imperial Hall on City Road to the recently opened Bower quarter with its shops and eateries. Not all the borough's recent buildings are enormous glass edifices, however, as a visit to No. 15 Clerkenwell Close will bear out. The work of architect Amin Taha, it is a seven-storey building that, due to its rough-hewn façade, brings emotions to the fore as it is so different to anything else in the vicinity. You either like it or hate it and I suspect it will remain controversial for a long time to come. In complete contrast the renovated National Youth Theatre's premises on the Holloway Road demonstrate how a former nineteenth-century Mission Hall can be transformed into a contemporary

Above: Cluster of tall modern buildings beside City Road.

Right: Eagle residential apartments, City Road.

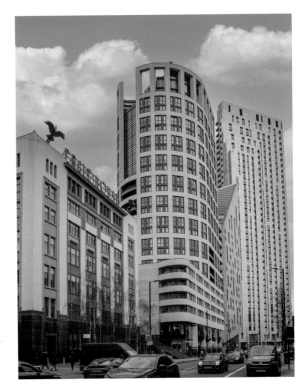

Left: No. 15 Clerkenwell Close.

Below: Zaha Hadid office and showroom, Goswell Road.

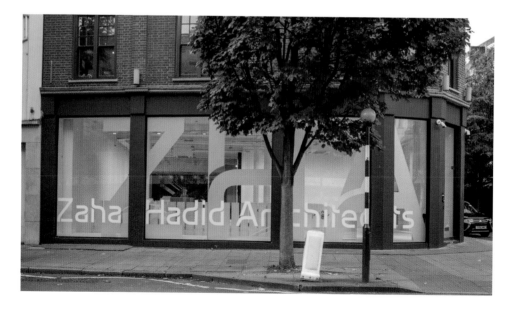

National Creative Production House retaining the building's Victorian style through careful and sympathetic design.

Nothing stands still in this borough and architects, many of whom have their studios in Clerkenwell, continue to push the boundaries. With famous names like Grimshaw, Zaha Hadid, BDP, Pollard Edwards Thomas, CZWG, Amin Taha and Wilkinson Eyre based here, the area continues to play an enormous role in design and has a great influence on many new builds both here and across London, as well as on the global scene.

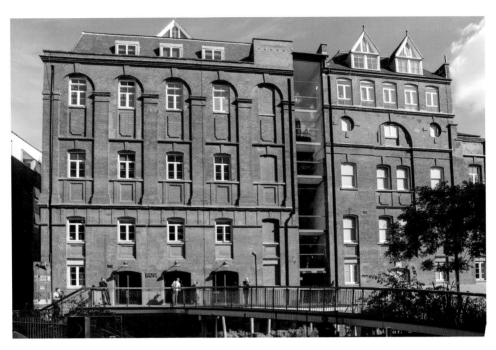

BDP Architectural Offices, Brewhouse Yard.

DID YOU KNOW?

1. The classical-style brick 'temple' found in the central gardens in Gibson Square is actually a ventilation shaft for the Victoria underground line running beneath the square. London Underground's original proposal for a concrete structure was met with such enormous opposition from local residents that Quinlan Terry was commissioned to design a more acceptable alternative.

2. The Business Design Centre on Upper Street was established in 1862 as the Agricultural Hall – which due to its great popularity was given the prefix 'Royal' following a visit by Queen Victoria. Famous for its circuses, balls, walking marathons and even dog shows, it appealed to the masses, as well as royalty, statesmen and the literati. After the Second World War the hall had become almost derelict but was saved from demolition by local businessman Sam Morris, who redeveloped the building in the 1980s and rebranded it to become a design and events centre.

3. The remarkably ornate façade of the Fox and Anchor pub on Charterhouse Street owes its design to William J. Neatby, the artist responsible for the exquisite interior of Harrods Food Hall.

5. Poverty, Prisons and Punishment

Walking along Islington and Clerkenwell's many gentrified streets today it is very hard to imagine that from the early seventeenth century they were once home to some of the country's most feared and loathsome prisons. Their location here may well have been due to their proximity to the City of London but perhaps the extreme destitution and poverty of the district that led to so many acts of crime and villainy explains the need for such buildings. Three types of prison – correctional, holding, and debtors', dominated the area. The early 1600s saw the erection of Clerkenwell's Bridewell. This was commonly known as a house of correction, that is one where prison conditions were generally harsh, and a strict regimen of regulations existed. In later years a house of detention was built nearby to the Bridewell to accommodate prisoners awaiting trial at Assizes. In 1813 a debtors' prison opened in Whitecross Street where anyone who owed money, regardless of their place in society, was incarcerated, be it for a few hours, days, or even a number of years. A grim new house of correction, Coldbath Fields, was established in the 1790s in the area near Exmouth Market. It was a large prison that operated within strong intimidating walls for the best part of a century, during which time it housed hundreds of convicts imprisoned for a wide variety of crimes. These ranged from the trifling to the most wicked and heinous.

In the wake of the Industrial Revolution vast numbers had moved into the area from all around Britain, as well as overseas immigrants who were fleeing persecution. Many lived in substandard and greatly overcrowded housing perhaps with more than one family sharing a room. Housing was tightly packed together in tenement buildings known as rookeries that were labyrinthine and allowed criminals to disappear from their pursuers through narrow hidden passages and trap doors. Poor health, unsanitary living conditions and tremendous hardship undoubtedly contributed to many being forced into a life of crime. Thieves, pickpockets and petty criminals were in abundance throughout the district, a situation that the great Victorian author Charles Dickens brilliantly portrayed in his famous book *Oliver Twist*, when his characters the Artful Dodger and Charley Bates introduced Oliver to the tricks of the trade when they stole a silk handkerchief from the genteel and elderly Mr Brownlow's pocket.

Early Courts of Law

The first court to be built in the area was Hicks Hall, which operated between 1612 and 1782. It was a purpose-built Sessions House for the Justices of the Peace (JPs) of Middlesex and the City of Westminster and functioned as a criminal court. It heard cases involving attacks, plots and minor transgressions against the state and was the main court of petty sessions and arraignment for more serious offences. Built on an island at the end of St John Street and close to Smithfield, the court building was paid for by Sir Baptist Hicks,

a wealthy fabric merchant, and the court subsequently took its benefactor's name. In the seventeenth century Hicks Hall was considered to be one of London's most significant courts. For it was here in October 1660 that a grand jury was convened to try twenty-nine of the men who had signed Charles I's death warrant, although the actual proceedings later took place at the Old Bailey Sessions House. By the late 1770s the building was in such a bad state of repair that a decision was taken to demolish it and transfer the court's business to a new building on Clerkenwell Green, the Middlesex Sessions House.

The location of Hicks Hall at the southern end of the Great North Road was used until the early nineteenth century as the central point from where distances from London were measured. This system of measurement continued even after the building was demolished in 1782. Later, Charing Cross took over its role and was designated as the notional centre of London (today found by the statue of Charles I on an island to the south of Trafalgar Square).

The Middlesex Sessions House opened in the same year that Hicks Hall closed and with its reputation for harsh sentencing it was always greatly feared by prisoners. A most imposing building constructed of Portland stone and embellished with a central portico, coat of arms, Ionic columns and medallions of Justice and Mercy, it was built to impress. The interior contained two courts, judges' robing rooms, dining rooms, consulting rooms and accommodation for the resident lawyers. Prisoners were kept in small windowless cells in the basement, and after sentencing it was common practice for those found guilty of their charge to be put on boats moored behind the courthouse on the River Fleet and transported overseas before an appeal against their conviction could be lodged.

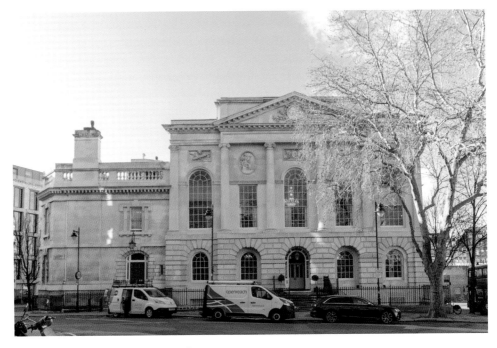

The Old Sessions House, Clerkenwell Green.

After the court closed in 1921 the building was occupied by the weighing machine manufacturer Avery Scales, then used as a Masonic Lodge and is now marketed as an all-day destination for work and leisure. Its grand and splendid interior rooms have been used for a variety of events including fashion shows, award ceremonies and art exhibitions. Since 1994 it has had Grade II* listed building status and has recently undergone a major restoration when great care was taken by the restorers to bring the building back to its original state to display its magnificent Georgian and Victorian features.

The Prisons

The earliest house of correction to be constructed was the Clerkenwell Bridewell set up in 1615 to cope with the overload from the City of London's prisons. A further prison, the New Prison, was built close by in the 1680s. This was a holding prison for those awaiting trial and it was from here in 1724 that the celebrated villain Jack Sheppard made his escape with his lover (he was later, after two further escapes from Newgate Prison, hanged at Tyburn). Over time the early buildings were demolished and in the mid-1840s a larger replacement prison, the Middlesex House of Detention, was erected to deal solely with prisoners awaiting trial. The prisoners stayed here only for a short while before appearing at the Middlesex Sessions House on Clerkenwell Green. The House of Detention was to become London's busiest prison with more than 10,000 people passing through its walls

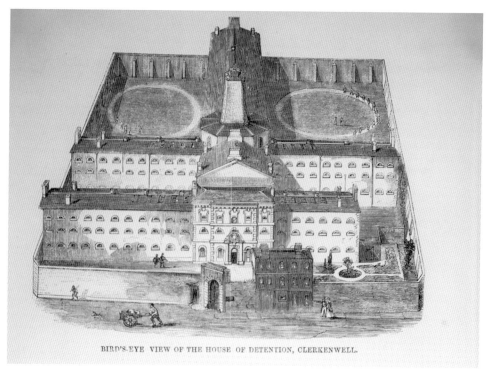

BIRD'S-EYE VIEW OF THE HOUSE OF DETENTION, CLERKENWELL.

Birds-eye view of the House of Detention, Clerkenwell. (Courtesy of the Wellcome Collection)

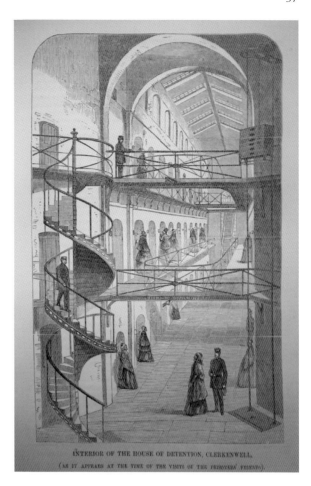

Interior of the House of Detention
Clerkenwell. (Courtesy of the
Wellcome Collection)

INTERIOR OF THE HOUSE OF DETENTION, CLERKENWELL.
(AS IT APPEARS AT THE TIME OF THE VISITS OF THE PRISONERS' FRIENDS).

each year. Prison life was strict; inmates had their own cells with a toilet, basin and small window up high. They had to keep their cells clean, but their days were spent without work, and they were compelled to exist in silence. They were even forbidden to sing, whistle, shout outside, in the cells or within the prison buildings. Although they were banned from communicating with their fellow prisoners, they were permitted to wear their own clothes and work materials and food could be brought in for them by visitors. Daily food rations were provided for the inmates, but the quantity depended on the age, length of stay, and gender of each individual prisoner. The building, covering a 2.5-acre site was largely cruciform in shape and consisted of three men's wings and one for the female prisoners. The House of Detention was not considered as fearsome as some of its neighbouring institutions and friends and relatives were permitted to visit daily between midday and 2 p.m. except on Sunday. The prison was closed in 1886 and demolished a few years later. The site was then built over by the Hugh Myddelton School, which retained some of the prisons' basement cells and tunnels and these were subsequently used as air-raid shelters during the Second World War. The school was closed in 1971 and today has been converted into luxury apartments known as Kingsway Place.

1861
Middlesex House of Detention,
Daily Diet List.

	Prisoners committed for 3 Months and upwards — Male and Female Adults						Under 3 Months — Male Adults				Under 3 Months — Female Adults				Males and Females under 17 Years of Age			
	Bread ozs	Cocoa pints	Meat when cooked ozs	Potatoes ozs	Soup pints	Gruel pints	Bread ozs	Meat when cooked ozs	Soup pints	Gruel pints	Bread ozs	Meat when cooked ozs	Soup pints	Gruel pints	Bread ozs	Meat when cooked ozs	Soup pints	Gruel pints
Sunday	20	1	6	8	--	1	20	6	--	2	16	6	--	2	16	4	--	2
Monday	20	1	--	--	1 1/2	1	20	--	1	2	16	--	1	2	16	--	1	2
Tuesday	20	1	6	8	--	1	20	6	--	2	16	6	--	2	16	4	--	2
Wednesday	20	1	--	--	1 1/2	1	20	--	1	2	16	--	1	2	16	--	1	2
Thursday	20	1	6	8	--	1	20	6	--	2	16	6	--	2	16	4	--	2
Friday	20	1	--	--	1 1/2	1	20	--	1	2	16	--	1	2	16	--	1	2
Saturday	20	1	6	8	--	1	20	--	--	3	16	--	--	3	16	--	--	3

N.B - Prisoners not receiving such allowances, are allowed to provide for themselves; and all Prisoners are allowed to be visited by their friends, from 12 till 2 daily, Sundays excepted.

House of Detention Daily Diet List.

Coldbath Fields, the Clerkenwell house of correction for the County of Middlesex, was built in 1794 at the site of a cold spring and pool and was founded with the intention of putting into practice new ideas of prison reform that had been pioneered by penal reformers such as John Howard. From the outset the prison was notorious for its severity and cruelty. In 1825 Coldbath Fields had a capacity of 600 but this had almost doubled to 1,150 by 1832. At the time it was England's largest prison and contained not only workrooms, cells, dormitories, and mess halls but also a large wheel room filled with treadmills.

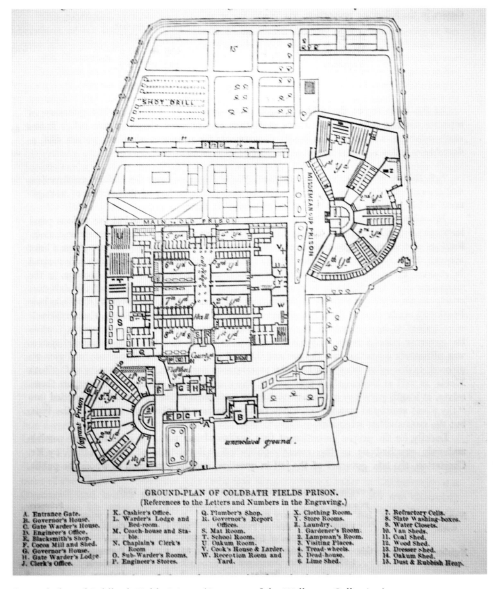

GROUND-PLAN OF COLDBATH FIELDS PRISON.
(References to the Letters and Numbers in the Engraving.)

A. Entrance Gate.	K. Cashier's Office.	Q. Plumber's Shop.	X. Clothing Room.
B. Governor's House.	L. Warder's Lodge and Bed-room.	R. Governor's Report Offices.	Y. Store Rooms.
C. Gate Warder's House.			Z. Laundry.
D. Engineer's Office.	M. Coach-house and Stable.	S. Mat Room.	1. Gardener's Room.
E. Blacksmith's Shop.		T. School Room.	2. Lampman's Room.
F. Cocoa Mill and Shed.	N. Chaplain's Clerk's Room	U Oakum Room.	3. Visiting Places.
G. Governor's House.		V. Cook's House & Larder.	4. Tread-wheels.
H. Gate Warder's Lodge	O. Sub-Warder's Rooms.	W. Reception Room and Yard.	5. Dead-house.
J. Clerk's Office.	P. Engineer's Stores.		6. Lime Shed.
			7. Refractory Cells.
			8. Slate Washing-boxes.
			9. Water Closets.
			10. Van Sheds.
			11. Coal Shed.
			12. Wood Shed.
			13. Dresser shed.
			14. Oakum Shed.
			15. Dust & Rubbish Heap.

Ground-plan of Coldbath Fields Prison. (Courtesy of the Wellcome Collection)

The prison's regime was exceptionally tough; work followed by religious instruction and then more work. Many prisoners spent their days in the wheel room or were involved in oakum picking. The former entailed hours of hard labour working on the treadmill. Prisoners had to climb the steps of the wheel and make it turn with their feet. Although some of the wheels were used to grind corn or raise water, most of them just ground the air and the whole exercise achieved nothing apart from keeping idle hands (or in this case feet) busy. Other prisoners, up to 500 at a time, found themselves involved in picking oakum. This required them to pick apart tarred ships' ropes, which then had to be re-spun into rope. It was not only horribly laborious and boring but also a very dirty job. The prison chose such menial work for its inmates on purpose, and it wasn't until the latter part of the century that more useful occupations, such as bag making, were introduced into the prison workshops.

Coldbath Fields contained every type of convict ranging from those who were professional criminals to those who had committed minor or one-off offences. Sadly, while they were incarcerated in the prison nothing was done to rehabilitate the convicts or train them in useful employment. Also, under the prison's 'Silent System' no prisoner was permitted to talk to any other prisoner. This was a technique, begun in 1834, that had been pioneered by penal reformers to prevent hardened criminals influencing those sentenced for less petty misdemeanours. Anyone found breaking the rules was subjected to punishments such as solitary confinement, having to wear leg irons, flogging, or bread

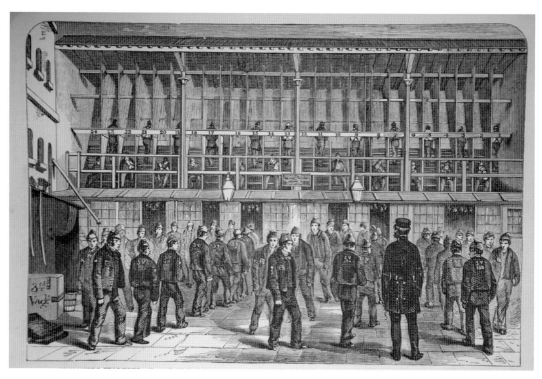

Prisoners working at the treadwheel at Coldbath Fields. (Courtesy of the Wellcome Collection)

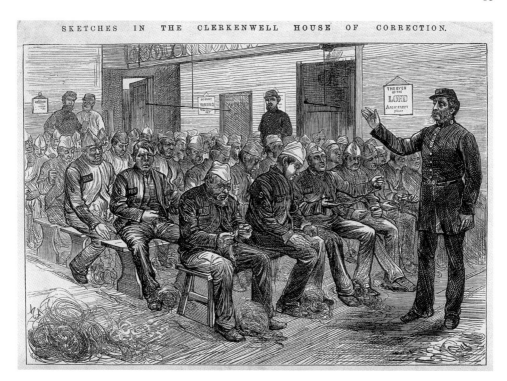

Oakum picking on site of former Coldbath Fields. (Courtesy of the Wellcome Collection)

and water diets. Naturally, prisoners found ways round the silence regulation and many new ways of communication evolved, like banging on the prison's pipes and using hand signals. Inmates also introduced their own language involving winks. It must have been exceptionally difficult for the prison officers and governor to control such a cohort of silent prisoners who despite all the institution's efforts managed to communicate using

Mount Pleasant
sorting office.

Mail Train engine. (© The Postal Museum/ Miles Willis)

their own private language. It is not surprising then that Coldbath Fields was commonly known as 'the Steel' after the infamous and greatly feared La Bastille prison in Paris. Finally, in 1885 the prison closed, its land was sold off and the inmates were transferred to Pentonville Prison on the Caledonian Road.

Pentonville and Holloway

In 1842 Pentonville opened as a 'new model' penitentiary and went even further than Coldbath Fields' Silent System by instituting the 'Separate System' whereby each inmate was kept in solitary confinement, sat in his or her own box in chapel and exercised alone. The prison's inspectorate believed that 'solitude inspires permanent terror' and this doctrine, along with enforced religious instruction, would deter prisoners from a life of crime and lead to their rehabilitation. Pentonville's prisoners were forbidden to speak and wore a uniform consisting of a brown jacket and trousers along with a cloth cap that had a large peak, known as a beak, obscuring their faces when outside of their cells. The punishment meted out for lifting the beak was severe and convicts could only be identified by a number on a badge on their jacket.

Pentonville was built in a new style that consisted of a radial plan of four wings with cells on both sides. Each of its 520 cells was the same size and all could be observed from a central point by prison staff. Initially the prison was set up to house convicts for a period of eighteen months before their transportation to Australia and Tasmania but as the Separate System began to fail and demonstrated its shortcomings (there were many suicides and cases of insanity) the time spent in Pentonville was reduced to nine months. Ultimately, some of the rigid rules were eased: inmates were able to sit alongside one another in chapel and even exercise together, though they were still compelled to carry out hard labour.

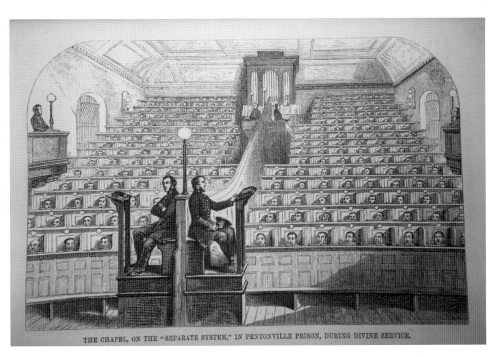

The chapel on the separate system in Pentonville Prison. (Courtesy of the Wellcome Collection)

A decade later Holloway Prison, looking more like a castle than a jail, opened on the Camden Road to take in the overspill from the City of London's prisons. Like Pentonville, it was built as a 'new model' prison and run under strict discipline. Its six wings could accommodate 450 prisoners, the majority of whom were male. Prison life was far from easy, and prisoners were only allowed visits or letters once every twelve weeks. Their days were spent largely on more productive tasks than at Pentonville, with prisoners either working on the treadmills that supplied water to the entire prison or in one of several industries such as bookbinding or tailoring. Towards the end of the nineteenth century after the publication of the Gladstone Report 1895 treadmills were abolished throughout the country's prisons and recommendations made for a move to productive labour and a reduction of time spent by prisoners in isolation.

In 1903 the Victorian Gothic institution was redesignated as a women's-only prison and continued to remain as such until 2016 when its doors finally closed. Holloway is perhaps most renowned today for the many suffragettes who were incarcerated within its walls in the early twentieth century. Despite the earlier recommendations for change that had been put forward by the Gladstone Report accounts from many suffragettes confirm that Holloway's regimen still operated on Victorian lines and life was extremely harsh. While in prison many of the women were subjected to solitary confinement, had steel restraints applied and were force-fed by staff when they went on hunger strike in furtherance of their cause, Votes For Women. The campaign's leader Emmeline Pankhurst and her daughters, Christabel and Sylvia, all spent time here, as well as numerous women of every age and from all social backgrounds. The prison has long been linked to the women's

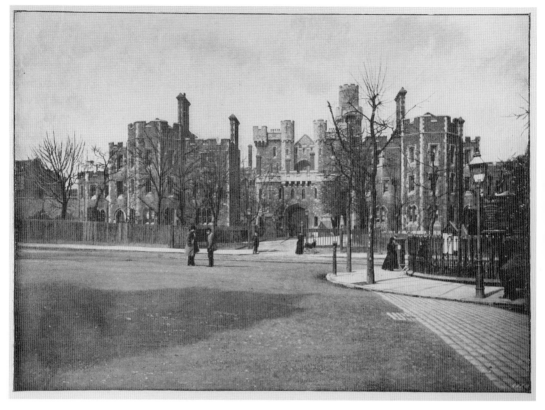

Holloway Prison.

liberation movement and modern-day feminists have claimed it as a proud part of their history.

Holloway was not only renowned for the suffragettes that passed through its doors but also heralded as Europe's largest women's prison. It is particularly famous for housing prisoners such as Ruth Ellis, England's last woman to be hanged, and the child killers Myra Hindley and Rose West.

In the early 1970s the entire Victorian Gothic prison was demolished and then completely rebuilt on the site with many more facilities including a gym, swimming pool, a pharmacy and even a roof garden. Very few items survived from the original institution, but one poignant artefact was a foundation stone inscribed 'May God preserve the City of London and make this place a terror to evil-doers.' Finally, a decision was taken to close Holloway and in 2016 its land was sold to the housing association Peabody. The site is presently being redeveloped to provide approximately 1,000 new homes, along with communal facilities and a 1.4-acre park.

Whitecross Street Debtors' Prison

When Whitecross Street prison opened in 1813 it was one of four debtors' prisons in London. The prisoners were subjected to a strict regime which was unbelievably boring

as they were locked up for sixteen hours of the day with no work to keep them busy. The period of sentence varied enormously and ranged from as little as two or three to ten days (the most common sentence), although some prisoners stayed for much longer – maybe five or even as much as ten years.

Whitecross Street was divided into six wards and no contact was permitted between them. Each ward accommodated different types of debtors, the poorest being the Dietary Ward. These prisoners were in such dire poverty that they existed on the prison diet alone with weekly rations consisting of cooked potatoes, a few pints of soup, a paltry amount of cooked meat, fourteen pints of oatmeal gruel and a few kilograms of wheaten bread. Each ward had its own large day room where fifty to sixty prisoners spent time eating, cooking, reading and smoking. There was no privacy, conditions were poor, and the prison exerted little discipline. Unusually, and not in keeping with the Houses of Correction and Detention families were often allowed to live inside the prison with the convicted debtor until his or her release. A good example of this practice is demonstrated by the incarceration of Charles Dickens' father, John, who found himself in Southwark's Marshelsea Debtors' Prison in 1824 for being in debt. Although Charles himself took lodgings outside of the prison his mother and siblings stayed inside it for the duration of John's sentence.

After the introduction of the Debtors' Act 1869 the practice of imprisoning people for debt was discontinued and in 1870 Whitecross Street prison was closed and its population transferred to Holloway Prison. The site of the prison is part of today's Barbican development.

DID YOU KNOW?

1. After Coldbath Fields Prison closed in 1885 the land was purchased by the Post Office that established its mail and parcel sorting offices here, renaming the site 'Mount Pleasant'. In 1927 it became the main terminus of Mail Rail – a miniature underground railway that transported mail on its carriages across London from Paddington in the west to the City of London in the east.

2. Irish Fenians attempted to blow up the House of Detention in 1867 to rescue two of their number, Burke and Casey. The explosion failed to release the prisoners but caused twenty-six deaths, much damage to surrounding buildings and left its scars on the prison's walls (still visible today). Michael Barrett, found guilty of the act, was convicted and hanged for the offence at Newgate Gaol in 1868, the last public execution to be carried out there.

3. Legend states that visitors to the Middlesex Sessions House today can still hear the wails of a woman sitting on its main staircase – apparently mourning the fate of her lover who, having been convicted of his crime, was transported to the colonies before the two could say their last goodbyes.

6. Radicals and Revolutionaries

Clerkenwell Green and its environs have been particularly associated with radicalism since at least the fourteenth century and yet a walk around the neighbourhood today gives no sign of what has been, at times, the scene of great turmoil. Why rebels protested, revolutionaries staged demonstrations and famous political groups such as the Chartists, suffragettes and socialists gathered here is a bit of an enigma. Yet the area seems to have had a special appeal to activists, strikers, and dissenters, as well as those championing the cause of the underprivileged. Interestingly, it is from the steps of the Marx Memorial Library that the May Day Parade to Trafalgar Square begins each year; the first having been organised more than 130 years ago by the Social Democratic Foundation (when it campaigned for an eight-hour working day). To all intents and purposes Clerkenwell Green has always been an ideal spot for people to congregate as it offers a large open space lying right between Clerkenwell's grand monastic estates.

Present-day Clerkenwell Green.

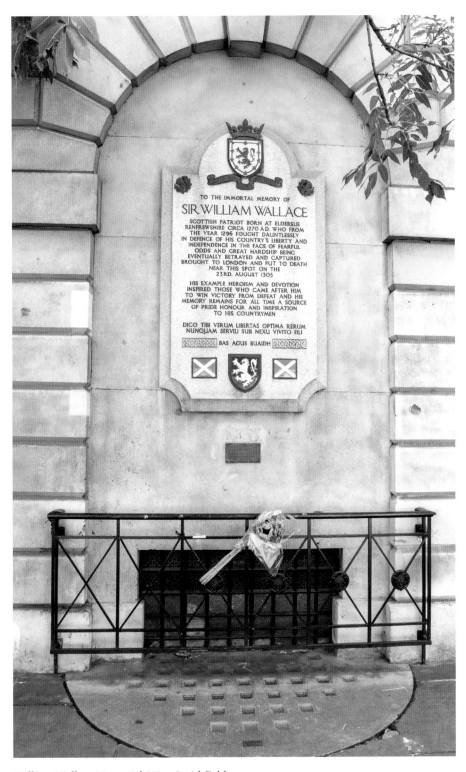

William Wallace Memorial, West Smithfield.

Nearby Smithfield was equally a suitable location for mass gatherings with its 'smooth field' and position right beside the City of London. Associated with revolutionaries, rebels, religious zealots and the scene of executions, hangings and burnings, Smithfield has certainly had a violent history; in 1305 the great Scottish patriot and hero William Wallace (c. 1272–1305) was put to death here. He had defeated Edward I's army at Stirling Bridge in 1297 but was then himself defeated a year later by the English; following a nine-year campaign against English rule he was ultimately captured and brought to the capital where he was hanged, drawn and quartered in Smithfield. A commemorative plaque sits on the wall of St Bartholomew's Hospital recalling Wallace's fight for Scotland's liberty and independence. It states that 'his example heroism and devotion inspired those who came after him to win victory from defeat and his memory remains for all time a source of pride honour and inspiration to his countrymen'. In 1381 Smithfield was once again the scene of horror when Wat Tyler, leading a band of men to London from the counties of Kent and Essex to demonstrate against the harsh government-imposed poll tax, was killed here. Before agreeing to meet the fourteen-year-old king Richard II at Smithfield, Tyler and the rebels had camped out on nearby Clerkenwell Green. Hoping not only to negotiate a deal on the poll tax but also to come to an agreement on the abolition of serfdom, of greater liberty and social reforms, the discussions initially looked promising. Unfortunately matters took a downward turn, which resulted in Tyler being fatally wounded by the king's representative, the Lord Mayor of London William Walworth. Tyler's death brought an abrupt end to what became known as 'the Peasants' Revolt' and his decapitated head was later displayed on London Bridge as a warning against such uprisings and the likely consequences for others contemplating such actions.

Smithfield was once again the scene of many killings during the sixteenth century in the wake of Henry VIII's break with the Church of Rome and his establishment of the Church of England. The Dissolution of the Monasteries of the 1530s led to a period of prolonged religious persecution and the subsequent deaths of many who refused to adopt Henry VIII's new Protestant religion. After Henry's death in 1547 many more lost their lives at Smithfield especially during the reign of the Catholic Mary Tudor (aka Bloody Mary, 1553–58), Henry's eldest daughter and progeny of his marriage to Katherine of Aragon. During this time scores of Protestants died for their faith and many were executed or burned at the stake. John Rogers, the English clergyman and Bible translator, was the first English Protestant to be executed here as a heretic. By refusing to renounce his religion and return to the Catholic church he became the first martyr of Queen Mary's reign and was punished by being burned at the stake. During the reigns of Henry VIII's offspring, Edward, Mary, and Elizabeth, hundreds were accused of being traitors and heretics and Smithfield for much of the sixteenth century was associated with the spilling of blood.

Clerkenwell and Islington continued to be home to those in contention with the authorities throughout the late eighteenth and nineteenth centuries. The famous radical politician and later Lord Mayor of London John Wilkes (1727–97) was one such man. Born in Clerkenwell, the son of the wealthy distiller Israel Wilkes, he was brought up in a substantial house on St John Square. At the age of thirty he entered Parliament and was the author of a radical satirical weekly journal *The North Briton*, in which he took the prime minister, Lord Bute, to task. In 1763 Wilkes was arrested and imprisoned in the Tower of

London (albeit for only a short time due to his position as an MP) after he asserted that ministers were putting lies into the king's mouth. When he gained his release, the crowds cheered and chanted 'For Wilkes and Liberty'. All through his life Wilkes was a great advocate of the freedom of the press, free speech and liberty and an ardent supporter of American independence. He was incarcerated in the Fleet Prison for a couple of years in the late 1760s but was later appointed an alderman, then a sheriff and finally Lord Mayor of the City of London. In 1774 he took up his seat again as a Member of Parliament. Despite being a constant thorn in the side of the establishment throughout his life, his radical activities did bring about political change and a greater democratic system. Today passers-by in New Fetter Lane will see a bronze statue of John Wilkes placed there to commemorate him as one of London's most radical and controversial eighteenth-century political campaigners.

Another political activist of the period Thomas Paine (1737–1809) was based in Islington while writing his famous book *Rights of Man (1791)*. Containing proposals for the relief of the poor, pensions for the elderly, public works for the unemployed and a scheme for popular education (all to be financed by imposing a progressive income tax), his book was met with extreme opposition. The authorities considered his ideas so revolutionary that Paine's book was banned. Paine fled overseas and was tried and found guilty of seditious libel in absentia.

Thomas Paine Memorial.

All through the 1800s Clerkenwell Green was the setting of demonstrations and became the headquarters of republicanism and revolution; the Chartists fighting for rights for the growing working classes assembled and held rallies here in the 1830s and 1840s, demonstrations and marches took place against the Irish uprising in the 1860s and figures such as George Bernard Shaw, Annie Besant, Eleanor Marx and William Morris attracted large crowds when they spoke here in the late nineteenth century. Around the same time No. 37A Clerkenwell Green, the present Marx Memorial Library, became home to the London Patriotic Society and then The Twentieth Century Press (TCP) both socialist organisations, the latter supported by William Morris. The Russian leaders Lenin and Stalin attended conferences in London around this time and it is believed by some that they held meetings at the Crown Tavern on Clerkenwell Green (a popular meeting place for radicals).

Nowadays a plaque adorns the wall of the former No. 16 Percy Circus (presently the rear of a hotel) where Lenin lived with his wife in 1905. A few years earlier Lenin had lived in Holford Square near the Pentonville Road, which was badly bombed during the Second World War. When it was being rebuilt the architect Berthold Lubetkin designed a memorial containing Lenin's bust and placed it in the newly designed square. However, during the period of the Cold War the memorial was vandalised a number of times so it

Marx Memorial Library, Clerkenwell Green.

Above: The Crown Tavern,
Clerkenwell Green.

Right: Plaque commemorating
Lenin's stay in Percy Circus in 1905.

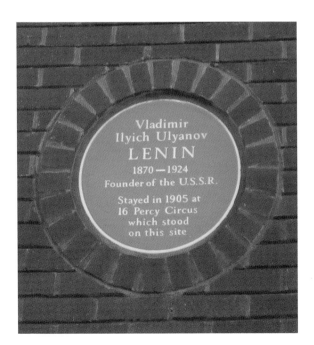

Lenin's study in
the Marx Memorial
Library. (© Marion
Macalpine)

was removed from its site and placed in safe storage in Islington's Town Hall for some years. Nowadays it has found a new and fitting home in the Islington Museum where it forms a key part of the museum's fascinating collection.

Mazzini, Garibaldi and Cavour

Following much political unrest across the Continent in the early nineteenth century many political exiles emigrated to London. In the late 1830s Giuseppe Mazzini (1805–72) took up residence in Clerkenwell having fled his native Italy due to his political activism and commitment to Italian unification. Arriving in the country in 1837 with a death sentence on his head, Mazzini was one of Italy's greatest patriots, a revolutionary and journalist who campaigned indefatigably for a united homeland free from foreign control. His Young Italy movement was an inspiration to the Italian general, nationalist and revolutionary Giuseppe Garibaldi (1807–82), who made several visits to England between 1848 and 1864 and the two men along with the statesman, Camillo Benso, Conte di Cavour (1810–61) are today recognised and acclaimed for the unification of modern-day Italy. While resident in Islington Mazzini not only used the area as his political base but also taught English to many Italian immigrants above a local barber's shop. He founded a school for poor Italian children and set up a social club, known initially as the Society for the Advancement of Italian Workers but in 1864 renamed the Mazzini-Garibaldi Club after Garibaldi's visit to Little Italy, with both himself and Garibaldi as joint presidents. The club was originally based in Mazzini's own home in the heart of Little Italy, and a bronze plaque displaying a bas-relief portrait of Mazzini with hands clasped now adorns the façade of No. 5 Hatton Garden. The club was used not purely for social purposes, a place where the Italian community could meet together, acquire knowledge and enjoy Italian customs, but also a place to drum up support within the area's Italian community for love of their native country and the nationalist cause.

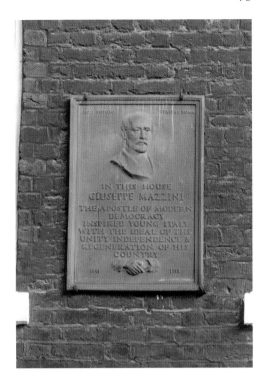

Giuseppe Mazzini plaque, Hatton Garden.

DID YOU KNOW?

1. While exiled in Clerkenwell in 1902–03 the Russian leader Lenin operated out of Twentieth Century Press's premises, at No. 37A Clerkenwell Green, to produce his revolutionary newspaper, *Iskra* (*The Spark*), which was then smuggled into Russia. His office on the first floor of the building can be visited when the Marx Memorial Library is open. Check opening times on www.marx-memorial-library. org.uk.

2. An unexpected memorial to the revolutionary Thomas Paine is located beside Angel underground station in the office complex, Angel Court. The eighteenth-century philosopher and political activist is said to have written the *Rights of Man* while lodging at the Angel Inn. Interestingly, the nearby Old Red Lion on St John's Street also claims to be the venue for his writing!

3. The popular Garibaldi Biscuit is named after the revolutionary and soldier Giueseppe Garibaldi, who became a great international hero and was hailed by the British public when he visited the country in 1861. It is thought that Peek, Frean & Co. who made the golden biscuits (consisting of two layers of soft buttery biscuit dough with sweet currants squashed between them) took advantage of the moment to launch their biscuit.

7. Charities, Philanthropists, and Famous Personalities

Why so many charities have chosen to station their head offices in Islington and Clerkenwell is a bit of a mystery, but I suspect there are good reasons for their presence in the area. Certainly, the district's history of poverty, disease and social deprivation may explain why charities dealing with health and social conditions have set up offices here, but over the years it has also become home to many other charitable bodies such as The Dog's Trust, Design Council and Greenpeace Environmental Trust (GET). GET offices situated within Greenpeace UK's headquarters are based in the handsome red and white brick Victorian Canonbury Villas, and Action Aid UK operates from offices in Bowling Green Lane near Exmouth Market. Other well-known charities in the area include the British Red Cross, St John Ambulance, Save the Children, the Stroke Association, and

The Dogs Trust, Wakley Street.

National Autistic Society, City Road.

the National Autistic Society, the latter two being located at opposite ends of the City Road. Since the time of the Industrial Revolution many stories have been written and sketches drawn of the area's destitute and impoverished population and despite Islington's seemingly gentrified wealthy persona today, much of the borough remains underprivileged and many still live in social housing. Islington and Clerkenwell, so close to the City of London, have always opened their doors to those fleeing oppression, the poor, the homeless, and workers unable to ply their trades in the City.

The early years of the seventeenth century saw two philanthropists make their mark on the locale: the first, unusually for the time, a woman, Dame Alice Owen (1547–1613). She had the fortune to have been married three times in her life, to a brewer, mercer and then a judge, and with each of her marriages had become increasingly rich. When her last husband died, she was able to buy land upon which she built almshouses for ten poor widows and a school for thirty boy scholars from Islington. Her motivation for establishing these institutions it is said came from a traumatic experience in her youth when she had been out walking in the fields with her maid servant. At the time the area was one frequented by practising archers and the story goes that quite by chance one of their arrows pierced the crown of her hat. Remarkably Alice was left totally unharmed, but her close shave with death led her to make a promise that should she ever become wealthy she would show her gratitude for her life by carrying out good deeds for the people of Islington. Her dream was realised in 1613 when she opened her boys' school

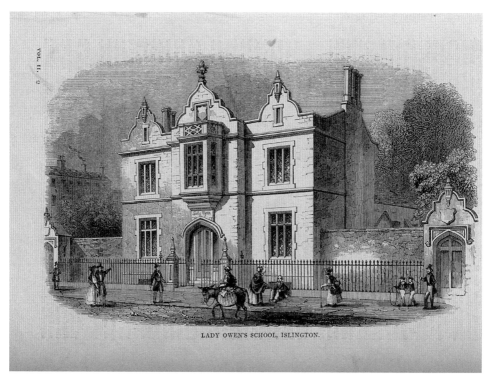

LADY OWEN'S SCHOOL, ISLINGTON.

Dame Alice Owen's School. (Courtesy of the Wellcome Collection)

and as a reminder of her story the school's coat of arms contains arrows. It also bears the barrels of the Brewers' Company, who are the school's trustees and who in line with Dame Alice's instructions visit the school annually and give 'beer money' to new pupils. In the late nineteenth century, the almshouses were demolished, and a girls' school was set up alongside the boys until the two schools merged in the early 1970s. In 1976 the school relocated to Hertfordshire and the land on which it had stood is now home to the City and Islington Sixth Form College. Today Dame Alice Owen is still remembered in the local street names such as Owen Fields, Owen Street and Owen's Row.

The second philanthropist was Thomas Sutton (1532–1611), reputedly the richest man in England at the time, who owned coal mines in the north-east of the country, was an arms dealer and also a moneylender to the Crown. His will established 'King James Hospital in Charterhouse' – an almshouse to accommodate eighty elderly men and a school for forty poor boys. The almshouse and school were built on the site of the former Charterhouse Carthusian Monastery (see Chapter on Monastic and Religious Houses) and although the latter has since moved out of London, the former is still very much in existence and continues to provide a home to a community of elderly residents who dine and share many communal activities together in wonderful Tudor buildings and beautifully maintained grounds.

In Victorian times in particular, poverty and dire housing was common. It was only alleviated by aid from religious bodies and the deeds of rich philanthropists who, shocked

Right: Thomas Sutton's tomb, Charterhouse.

Below: The Great Hall, Charterhouse.

Peabody Housing,
Clerkenwell.

by the conditions, they witnessed provided respectable homes to the poor at inexpensive rents.

One such philanthropist was the American financier George Peabody (1795–1869). He was so appalled by London's filthy and sordid tenements and the lack of clean accommodation available for the 'decent poor' that in the early 1860s he donated £500,000 to fund the construction of good, sanitary housing estates throughout the capital. Clerkenwell's Pear Tree Court opened in 1884 and consisted of eleven five-storey blocks that surrounded a central courtyard. There was a laundry room on the top of each block and tenants shared toilets and sculleries. All residents had to be vaccinated against smallpox and under the conditions of their tenancies were bound to keep communal areas clean. The estate, with its almost prison-like appearance and constructed out of London stock and white Suffolk bricks, remains a landmark today. Despite its somewhat austere looks it has been a continuous and excellent provider of safe, affordable and healthy housing to those in lower-paid regular employment for almost 140 years. Initial residents included shop assistants, constables, printers, and tailors but nowadays many others meet Peabody's eligibility requirements and present-day tenants include frontline key workers such as those employed in the health and social care industries, in education and in the emergency services.

Peabody was not alone in supporting Islington's respectable poor. At the dawn of the twentieth century Samuel Lewis (1837–1901), an eminent rich moneylender, provided an endowment of £670,000 (now worth about £30 million) to establish a charitable trust to provide housing for the poor. The first of his developments was built in 1910 as an estate consisting of six parallel blocks of five-storey buildings on Liverpool Road, which today has Grade II listed status. Like the Peabody housing the estate is an imposing site and easily recognisable on account of its warm red-brick exterior. The Samuel Lewis Housing Trust is now known as the Southern Housing Group and is one of southern England's largest housing associations.

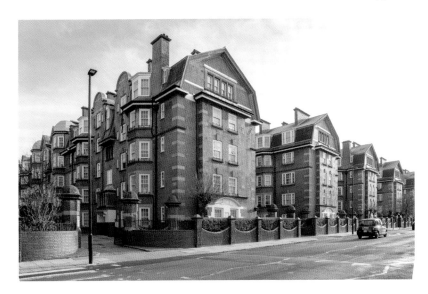

Samuel Lewis
Buildings,
Liverpool Road.

A third housing estate was built by the Sutton Dwellings Trust on Upper Street in 1924 for the respectable working classes of Islington. William Richard Sutton (1833–1900) was a very successful businessman (who had run a door-to-door parcel delivery service) and, like Samuel Lewis, he left a large sum of money on his death to provide housing for the poor. His will was immediately contested by his family as he had never shown any interest in philanthropy whilst alive, yet the court upheld its legitimacy, and the Sutton Dwellings Trust was set up with the Upper Street homes being erected after the establishment of earlier estates in North London, Chelsea and Rotherhithe.

John Groom's
home and flower
girls' mission
building, Sekforde
Street.

Another man whose name lives on in the area is John Groom (1845–1919). A committed Christian and evangelical preacher, he was by trade a silver engraver who lived and worked at No. 8 Sekforde Street in Clerkenwell. At the age of twenty-one he founded 'John Groom's Watercress and Flower Girls Christian Mission', which still continues its work today on behalf of the disabled. It is now known as the national charity, Livability, and after having merged with the Shaftesbury Society in 2007 is the UK's largest Christian disability charity. Groom was extremely concerned about the plight of the area's young girls who lived in Clerkenwell's wretched and seedy rookeries, slums that were frequently without heating, food, sanitation, or furniture. These youngsters were often seen begging on the streets, used as cheap child labour or became child prostitutes just to survive. Groom established his mission in the area where he tried to make life better for the young girls by training them for domestic service where he hoped they would be safe and have a home away from the streets. He was particularly concerned about the disabled girls who could not work and were therefore unable to provide for themselves. His answer to this problem was to employ them to make artificial flowers that were extremely popular at the time, and they became known as 'flower girls'. He not only paid the girls a small salary but also provided homes for them to live in along Sekforde Street. It was his girls who provided the handmade roses in the streets every June on Alexandra Rose Day – a custom begun in 1912 by the Danish queen, wife of King Edward VII, to help London's hospitals that continues to this day.

An English Heritage blue plaque hangs on the wall of his Clerkenwell home in memory of a truly remarkable, great and caring man.

Famous Residents and Literary Associations

It is an impossible task to chronicle the great numbers of famous people who have been or are still associated with Islington and Clerkenwell, so I have concentrated on writing about a small and varied selection of its residents and hope that they will provide you with a glimpse of the quarter's rich and diverse heritage.

As mentioned previously, the area has always attracted the nobility, the wealthy, the clergy, politicians, statesmen, entertainers, revolutionaries, as well as actors, artists and writers.

As far back as the eleventh century monarchs attended the Mystery plays performed outside Clerkenwell's springs on the banks of the River Fleet and in the 1200s St John's Gate was known to have hosted in its estate several royal guests. In the latter 1300s the Gate's Grand Prior, Sir Robert Hales, held the title of Lord High Treasurer, Chancellor of the Realm, and as such was the third most powerful man in England after the King and Archbishop of Canterbury. Sadly for him, as he had been responsible for introducing a most unpopular and hated poll tax, he got his comeuppance during the 1381 Peasants' Revolt when he was murdered by an angry mob on Tower Hill.

Writers have always written about events within the borough or have chosen to live here. In the late 1500s William Shakespeare (1564–1616) was closely associated with St John's Gate as this was where he came to get his plays licensed by the Revels Office. The playwright and author Ben Jonson wrote his comedy of manners, *Bartholomew Fair*, in 1614 in which he described in great detail the antics of Smithfield's annual fair, and the

diarist Samuel Pepys made further references to the fair in his diary note of 1 September 1668.

During the 1700s Dr Samuel Johnson (1709–84) wrote articles for *The Gentlemen's Magazine* at its offices in St John's Gate and the Irish novelist Oliver Goldsmith (1730–74), famous for his book *She Stoops to Conquer*, and the American short-story writer Washington Irving (1783–1859) both lodged in Canonbury Tower, although in different periods of time. Charles Dickens (1812–70) describes in *Oliver Twist* the horrors of living in Clerkenwell, the stench and filth of the market and the villainy of its low life, in particular the pickpocketing of Mr Brownlow.

Another Victorian author who wrote vividly about the poverty of the area was George Gissing (1857–1903). In his book *The Nether World* he describes the nearby Farringdon Road: 'What terrible barracks, those Farringdon Road buildings ... the weltering mass of human weariness, of bestiality, of unmerited dolour, of hopeless hope, of crushed surrender.' In the twentieth century the author George Orwell lived at No. 27b Canonbury Square when his book *Animal Farm* was published and while writing parts of his dystopian novel *1984*.

George Orwell's house,
Canonbury Square.

The borough also has links with a number of artists; the social observer, engraver and painter William Hogarth (1697–1764) was born in the district, baptised in the church of St Bartholomew the Great and lived as a young boy in St John's Gate where his father ran a coffee house. George Cruikshank (1792–1878), the leading caricaturist of his age, lived in Amwell Street and is forever remembered for his illustrations of Oliver 'asking for more' and 'Fagin in the condemned cell' in Dickens' book *Oliver Twist*. Kate Greenaway (1846–1901), the children's illustrator and artist, is commemorated with a green London Borough of Islington plaque on her home at No. 147 Upper Street where she lived from 1852 to 1873, and nearby at Highbury Corner there is another green plaque to the artist Walter Sickert (1860–1942) at No. 1 Highbury Place where he set up a school of art and a studio between 1927 and 1934.

Other celebrated names include the Methodist preacher John Wesley (1703–91), who founded his chapel on the City Road and brought Christianity to the masses in the eighteenth century, the poet laureate John Betjeman (1906–84), who was born and brought up in the borough and was personally involved in saving the Marx Memorial Library from demolition in the 1960s, and the 'Father of all Clowns' Joseph Grimaldi (1778–1837), who performed from the age of three at Sadler's Wells Theatre and brought tremendous joy to audiences throughout his lifetime with his amazing energy, vitality and wonderful comic talent.

In recent times two former prime ministers, Tony Blair and Boris Johnson, have chosen to live in Islington, the former in Barnsbury, the latter alongside the Regent's Canal close to Angel underground station.

Walter Sickert's house and studio, Highbury Place.

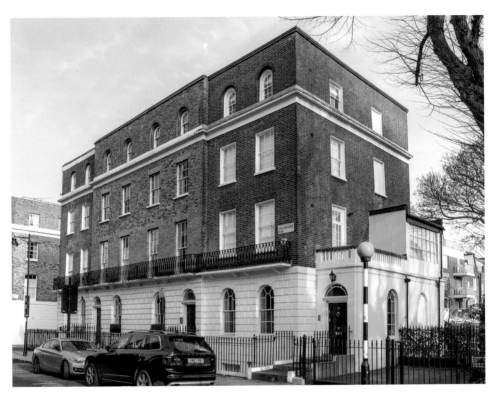

Former home of Boris Johnson, Colebrooke Row.

DID YOU KNOW?

1. Legend states that in the mid-1600s the feisty daughter of Sir John Spencer, Lord Mayor of London and favourite courtier of Queen Elizabeth I, escaped via a basket from her room in Canonbury Tower to elope with her penniless lover Lord Compton. The queen somehow managed to bring about a reconciliation between father and daughter and in time Compton inherited his wife's wealth and became the Earl of Northampton.

2. The author William Makepeace Thackeray used his experiences at Charterhouse School as the model for 'Slaughterhouse' in his famous masterpiece *Vanity Fair*.

3. George Peabody, the financier and founder of the Peabody Estates, on his death in 1869 was given a funeral and then interred in Westminster Abbey. The service was attended by both Queen Victoria and her son the Prince of Wales. Just three weeks later, in keeping with the conditions of his will, his body was exhumed and returned to his hometown of Danvers, Massachusetts, later to be renamed, Peabody.

8. Entertainment and 'Supper Street'

Islington has always been a fun-loving district associated with entertainment. In the Middle Ages people flocked to the area to attend the annual religious plays beside the Clerks' Well and later in Tudor times animal sports of cockfighting, duck hunting and bullbaiting were highly popular events. During the seventeenth century fist fighting and wrestling were fashionable sports with the lower classes too.

Many wealthy Londoners keen to leave the polluted city streets chose to spend time in Islington's countryside acclaimed for its clear fresh air, forest, streams, and meadows – an ideal place for recreation, somewhere quiet to stroll, hunt wild animals, play bowls and practice archery. The end of the 1500s witnessed the appearance of several theatres, such as The Fortune near Old Street and the Theatre and Curtain on Islington's boundary in Shoreditch. These proved to be extremely successful ventures and attracted large, if sometimes boisterous, audiences. During the eighteenth century as Islington became more industrial its landscape changed and within only eighty years a great deal of its fields and meadows were built over and replaced by factories, workshops and warehouses. As more and more people moved to the district to work its population increased exponentially, which led to both an urgent need for housing and better local facilities. A major effect of these changes was the desire for more and new entertainment venues. Music halls were a major draw from the mid-nineteenth century and cinemas gained immediate popularity when they appeared along Islington's streets in the early 1900s. The Great North Road (today's Holloway Road and Upper Street) had been lined with pubs and taverns for hundreds of years, used daily by the shepherds and drovers bringing their cattle and sheep to market at Smithfield until the mid-nineteenth century. Although many of these pub buildings are still in existence, it is not unusual now to see new and entirely different businesses operating from their premises. In fact, several of Upper Street's longstanding taverns and coaching inns have been transformed into clubs, restaurants, and cocktail bars. The entire street is nowadays filled with every eating venue imaginable and is such a culinary hub that it is has been dubbed 'Supper Street' – an entirely appropriate title for the number and wide range of cuisine on offer here. It seems that every budget is catered for and there is an excellent mix of chain and independent outlets offering food from across the globe.

The area also boasts a surprising number of theatres, cinemas and museums and in keeping with twenty-first-century living many gyms and leisure centres are found throughout the borough.

The early Elizabethan and Jacobean playhouses such as the Theatre and Curtain were renowned for staging the plays of William Shakespeare and his contemporaries Christopher Marlowe and Thomas Dekker. The Theatre was opened first in 1576 but within twenty years had moved from its site over to Southwark and was renamed the

Above left: The Red Lion Theatre pub, St John Street.

Above right: The King's Head Theatre and Pub, Upper Street.

Globe Theatre, becoming home to Shakespeare's company, the Lord Chamberlain's Men. Shakespeare's company had previously performed at the Curtain (London's second playhouse that had opened in 1577) where William was not only one of the actors but also one of its playwrights (along with Ben Jonson). Another theatre, the Fortune, leased by the famous actor Edward Alleyn and theatrical entrepreneur Philip Henslowe, opened at the corner of Whitecross Street in 1600. It was easy to find as a statue of the Goddess of Fortune hung over its entrance and unlike many of the playhouses of the period it was rectangular in shape and made of wood. The cost of tickets was one penny (1*d*), the best part of a days' wages at the time, or two pennies (2*d*) for those wanting to sit up in the galleries. Theatregoers in the Elizabethan era were much more involved in the performance than today; the groundlings (those who stood in the pit) would often be noisy, even rowdy. The players, all men, would only know their own lines, and perhaps the last few words before their own, so the performances were not nearly as smooth and well-rehearsed as present-day theatre productions. The playhouses continued to pull in the crowds until the mid-seventeenth century when the Puritans under Oliver Cromwell's command closed them down. Sadly, nothing now exists of the Fortune theatre; what

The Almeida Theatre, Almeida Street.

had been such a major entertainment venue is commemorated solely by a plaque on the theatre's site in Fortune Street.

Nowadays, Islington's best-known theatre is the Almeida located just off Upper Street. Since it opened here in 1980 it has earned itself an outstanding reputation and many of its productions have subsequently been transferred to London's West End, as well as Broadway. The Almeida stages a huge variety of plays and is renowned for its exciting and sometimes offbeat productions, as well as its strong casting and direction. Audiences are continuously thrilled with its international programme that includes Moliere, Chekhov and Greek tragedy, as well as classic Shakespeare and contemporary writing. As you would expect, many famous actors have appeared in its productions including Juliet Stephenson, Ralph Fiennes, Helen McCrory, Benedict Cumberbatch, Indira Varma, Simon Russell Beale, Ben Whishaw and Victoria Hamilton. As a result, the Almeida today has a very large and loyal clientele.

A stone's throw away behind St Mary's Parish Church is the charming Little Angel Theatre (LAT), a children's theatre entirely devoted to puppet and marionette shows. It is one of very few such venues in the country and operates within a former temperance hall just behind Upper Street. The theatre was founded by John Wright, a South African master puppeteer, and since its birth in 1961 has continued to delight both children and adults alike. Nowadays, the productions are put together and puppets created and carved in the workshop that sits alongside the theatre. LAT runs regular training courses for puppeteers and puppet makers in its premises to ensure that such specialist skills are not lost for future generations and also provides regular theatre activities and is highly involved with local schools and the community.

Sadler's Wells is possibly the area's most well-known venue, which is not surprising as it has occupied its site for more than 300 years! From its beginnings as a music hall

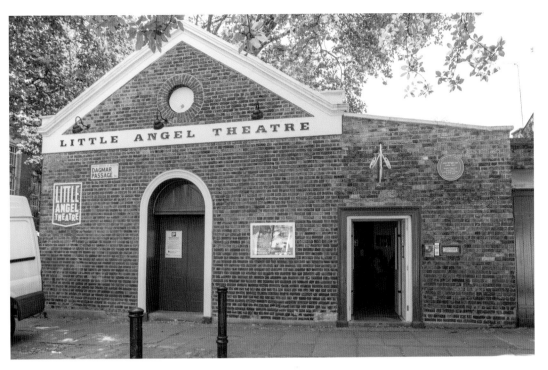

The Liittle Angel Theatre, Dagmar Passage.

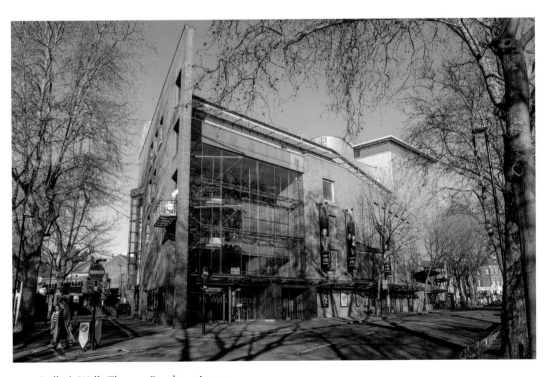

Sadler's Wells Theatre, Rosebery Avenue.

and spa resort it has continually provided entertainment, be it juggling, trapeze or clown acts like those of the 'father of clowns' Joey Grimaldi. It has also been home to a cinema and today's theatre is considered to be one of London's greatest performance venues. Its main specialty is contemporary dance, and the theatre regularly provides its stage for visiting companies from around the world to present their works. Here you will see Spanish flamenco dancing, Peking Opera and Chinese dance theatre, South American dance troupes, as well as classical and modern ballet. Sadler's Wells in recent years has become particularly celebrated for its staging of productions by the internationally acclaimed choreographer Matthew Bourne. Fans eagerly await his latest productions, which not only contain striking and alternative interpretations of much-loved classics but offer magnificent costumes and scenery too. In the twentieth century the theatre was the home of both the Royal Ballet and Royal Opera companies, and Lilian Baylis, the theatre's producer and manager of the time, is now remembered in the more experimental Lilian Baylis studio theatre sitting beside the main theatre on Rosebery Avenue.

Theatre-pubs, such as the King's Head, Old Red Lion, Hope and Anchor and Hen and Chickens, are a major part of Islington's entertainment scene too. These four, all located between Angel junction and Highbury Corner, attract regular audiences. The King's Head theatre opened in 1970 and like the Almeida Theatre has, in the ensuring decades, put on a great number of excellent productions and launched the careers of many actors. Other theatres in the borough include the National Youth Theatre in Holloway and the Park Theatre in Finsbury Park and both stage a programme of shows, musicals and plays.

Lilian Baylis Studio, Rosebery Avenue.

Music Halls

The Victorian era saw the emergence of another form of popular entertainment, the 'Music Hall' that took the capital by storm from the early 1840s. Islington was quick to follow the trend and several music halls were established in and around the Angel, as well as on the City Road where the Eagle and Grecian became all the rage. Customers, eating, drinking and smoking amid the entertainments on offer joined in the singing and were very much part of the entertainment. Admission was free but food and drinks had to be purchased and this was where the venues made their money. Initially music halls were based in pubs, drinking taverns and supper rooms that provided musical entertainment, but later some were purpose-built with huge halls and attracted enormous audiences. This was where many singers of the day launched their careers and made names for themselves. Performers such as Marie Lloyd, George Robey, Charlie Chaplin, Harry Lauder, Dan Leno, and Albert Chevalier all graced the London venues and many of their songs became national favourites.

Tower of former
Angel Picture Theatre,
Islington High Street.

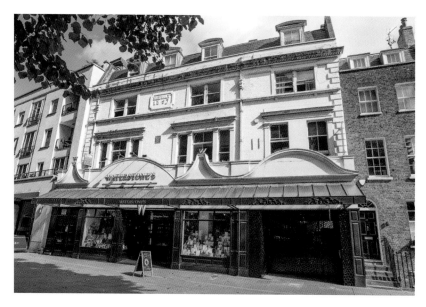

Former Collins
Music Hall,
Islington Green.

Collin's Music Hall was one of the district's best-loved sites, owned and managed by a Londoner and former chimney sweep called Sam Vagg, who was also known as Sam Collins. A talented singer, he had made his name singing Irish songs on the music hall and pub circuit and in 1861 took over the running of what had been a singing room overlooking Islington Green and converted it into a 700-seat music hall. An immediate success, Collins boasted a host of famous names and played to packed audiences. Throughout its lifetime the building was redeveloped many times and ultimately as music halls lost their popularity, repertory and variety shows took over from them. Collins remained a great name and Gracie Fields, Norman Windsor, Benny Hill, Tommy Cooper and Tommy Trinder all performed on its stage before the building finally closed in the late 1950s. Today the building, redeveloped in the Regency style, is home to a Waterstones bookstore and bears a blue plaque above its canopy commemorating its use as Collins Music Hall from 1862 to 1958.

Royal Agricultural Hall

What we now know as the Business Design Centre started life in the early 1860s as a hall for the Smithfield Club's annual livestock and agricultural exhibitions. An immense space (larger than Alexandra Palace), it has an enormous wide-spanned vaulted roof and cast-iron gallery and railings that make it resemble a Victorian railway station. From the start it was highly successful attracting large crowds and was used for events such as walking races, military tournaments, and even Crufts Dog Show. Known as the 'Aggie', it attracted people from every walk of life including the writer Charles Dickens and the nineteenth- and twentieth-century politicians Gladstone and Churchill. Over time it became quite dilapidated but was returned to its original state by a local businessman, Sam Morris, in the 1970s and transformed into its present use as a conference and exhibition centre.

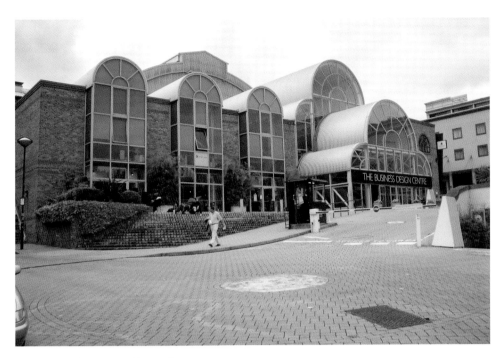

Business Design Centre, Upper Street.

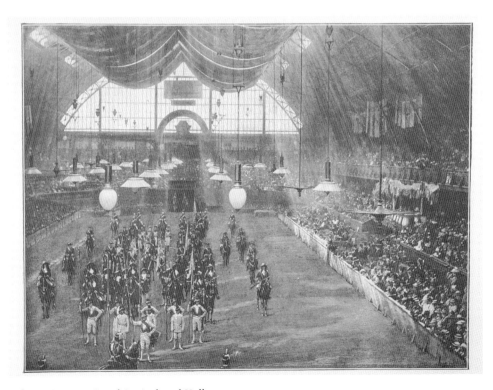

Military Pageant, Royal Agricultural Hall.

From the early 1900s Islington was hugely associated with film industry – home to the country's first cinema and the first talkie film show. The Gainsborough Film Studios opened on Poole Street in the 1920s and soon became particularly celebrated due to a certain Alfred Hitchcock, who became a major force at the studios. His movie *The Lady Vanishes* became the studio's most successful film of the 1930s, but as cinema numbers dropped off after the Second World War Gainsborough was forced to close in 1949. Despite having once been a major employer in the area, today all that reminds us of its name is a sign that sits on the building's façade, and it now houses luxury canal-side apartments not film studios. A huge bust of Hitchcock's head stands in its forecourt.

Cinemas still remain popular in Islington – there are three cinema sites in the Upper Street area alone (in the Angel Central shopping centre, Islington Square and opposite Islington Green) – yet in the early twentieth century there were many more competing for business in and around this part of town. Although most have long since gone, Upper Street's iconic 'Screen on the Green' remains in business over a century after its original construction and despite having changed its usage in recent years you can still see the domed façade of the former Electric Theatre at No. 75 Upper Street.

In nearby Essex Road the former Carlton Cinema (now Gracepoint) with its art deco style and Egyptian theme is a wonderful example as to how elaborately decorated cinemas were in the 1930s and how revered they were by cinemagoers as a place of entertainment.

Former Carlton Cinema, Essex Road.

The Gaumont too in the Holloway Road (today's Odeon) is another similarly striking art deco cinema. With an original seating capacity of more than 3,000 it is a massive imposing building that sits on a huge corner plot at its junction with Tufnell Park Road.

Islington and Clerkenwell are areas not only filled with entertainment venues but also are home to thriving shopping districts in Upper Street, Exmouth Market, Highbury, Holloway, Camden Passage and in many pockets around the borough. There are also several fascinating and quirky museums and galleries scattered across the district such as St John's Gate (once the London headquarters of the Knights Hospitaller), the Estorick Collection of Modern Italian Art, the London Metropolitan Archive, Victoria Miro Gallery and the Islington Museum.

It is certainly a very popular part of London and attracts people from every background, age group and walk of life.

DID YOU KNOW?

1. The present-day Starbucks at No. 7 Islington High Street fills the site of what was one of Islington's most luxurious cinemas when it opened in 1913 as the Angel Picture Theatre. Easily identified by its tall, impressive green domed tower, its interior was extremely plush and had an auditorium decorated with pillars and a superb plasterwork ceiling. The cinema, with a capacity of 1,463 seats, was the venue for Islington's first talkie movies and remained in operation until 1972, after which most of it was demolished apart from the tower.

2. No. 127 Upper Street – the Granita Restaurant until 2003 – was where Tony Blair and Gordon Brown completed a pact agreeing that Brown would not contest Blair for leadership of the Labour Party after the death of John Smith in 1994. Tony Blair in return promised Brown leadership in the future. The Granita closed down in 2003 and since then has been home to a Tex-Mex restaurant, an estate agents and more recently the sales office of Islington Square, the newly developed housing and retail complex.

3. St John's Gate Museum galleries open Wednesday to Saturday, 10.00–17.00, and recount the unique story of the Knights of St John of Jerusalem, who began their role in the eleventh century caring for sick pilgrims in the Holy Land. Guided tours of the building's beautiful historic rooms, church and crypt take place regularly and visitors not only learn about the order's past but also its modern-day role with St John Ambulance, the international first-aid charity.

Bibliography

Allen, Tudor, *Little Italy. The Story of London's Italian Quarter* (Camden Local Studies and Archives Centre, 2008)

Connell, Jim, *An Illustrated History of Upper Street Islington – Parts I & II* (Stowlangtoft Press, 1989, 1991)

Cosh, Mary, *A Historical Walk along the New River* (Islington Archaeology and Historical Society, 2001)

Cosh, Mary, *A History of Islington* (Historical Publications Ltd, 2005)

Draper, Chris, *Islington's Cinemas and Film Studios* (London Borough of Islington)

Hidson, Roy, *People, Places & Plaques. Commemorative Plaques Erected in Islington* (Islington Council 1993)

Manley, Bill, *Islington Entertained* (London Borough of Islington, 1990)

Pinks, William, *The History of Clerkenwell* (Charles Herbert, 1881)

Richardson, John, *Islington Past* (Historical Publications Ltd, 1988)

Shields, Pamela, *Essential Islington* (Sutton Publishing, 2000)

Sugden, Keith (ed.), *Criminal Islington* (Islington Archaeology and Historical Society, 1997)

Tames, Richard, *Clerkenwell and Finsbury Past* (Historical Publications, 1988)

Usborne, Ann, *A History of Islington* (Damien Tunnacliffe, 1981)

Willats, Eric A., *Streets with a Story. The Book of Islington* (Islington Local History Trust, 1988)

Zwart, Pieter, *Islington. A History and Guide* (Sidgwick & Jackson Ltd, 1973)

Please note that this is far from a comprehensive list as there are so many sources available. If you are inspired to discover more about the history of the area, I suggest you pay a visit the Local History Centre based in Finsbury Library at No. 245 St John Street, EC1V 4NB, or the Metropolitan Archives at No. 40 Northampton Road, EC1R 0HB.

Some useful websites are:
www.british-history.ac.uk
www.historicengland.org.uk
www.islington.gov.uk

Acknowledgements

The author would like to thank all the people and organisations that have facilitated the production of this book. In particular to acknowledge the help and assistance given by staff at the Wellcome Collection, the Marx Memorial Library, the Charterhouse, Wesley's Chapel, the Union Chapel and the Postal Museum.

Once again, I must commend my husband, Alex McMurdo, for producing such wonderful images and for his strong support and encouragement during the writing of this book. Please note that all images displayed without credit are his work and copyright. I also want to thank him and Joanna McMurdo for proofreading the text and for providing most valuable feedback and constructive criticism.

I would also like to take this opportunity to thank Amberley Publishing for commissioning the book, and to acknowledge the excellent support and hard work of Jenny Bennett, Becky Cadenhead, Nick Grant, Marcus Pennington and all the team.

About the Author

Lucy McMurdo is a modern history graduate and native Londoner who has lived in the capital all her life. In 2003 when she qualified as a London Blue Badge Tourist Guide she combined two of her major loves, history and London, and has been sharing her knowledge of the city with local and foreign visitors ever since. Always keen to explore and learn about London's secrets, she spends many hours 'walking the streets' looking out for hidden corners and unusual curiosities, as well as architecturally significant buildings and ones that have a story to tell.

Lucy's tour guiding career began over thirty years ago when she first guided overseas visitors around the UK. Since then, in addition to tour guiding, she has been greatly involved in training and examining the next generation of tour guides. She has created, taught and run courses in London's University of Westminster and City University and also developed guide-training programmes for the warders and site guides at Hampton Court Palace.

Most recently Lucy has been writing about the city she is so passionate about and is the author of nine London guidebooks: *Southwark and Blackfriars in 50 Buildings*, *The City of London in 50 Buildings*, *Hampstead and Highgate in 50 Buildings*, *Islington and Clerkenwell in 50 Buildings*, *Chiswick in 50 Buildings*, *Bloomsbury in 50 Buildings*, *Explore London's Square Mile*, *Streets of London* and *London in 7 Days*.